PENN STATION, NEW YORK

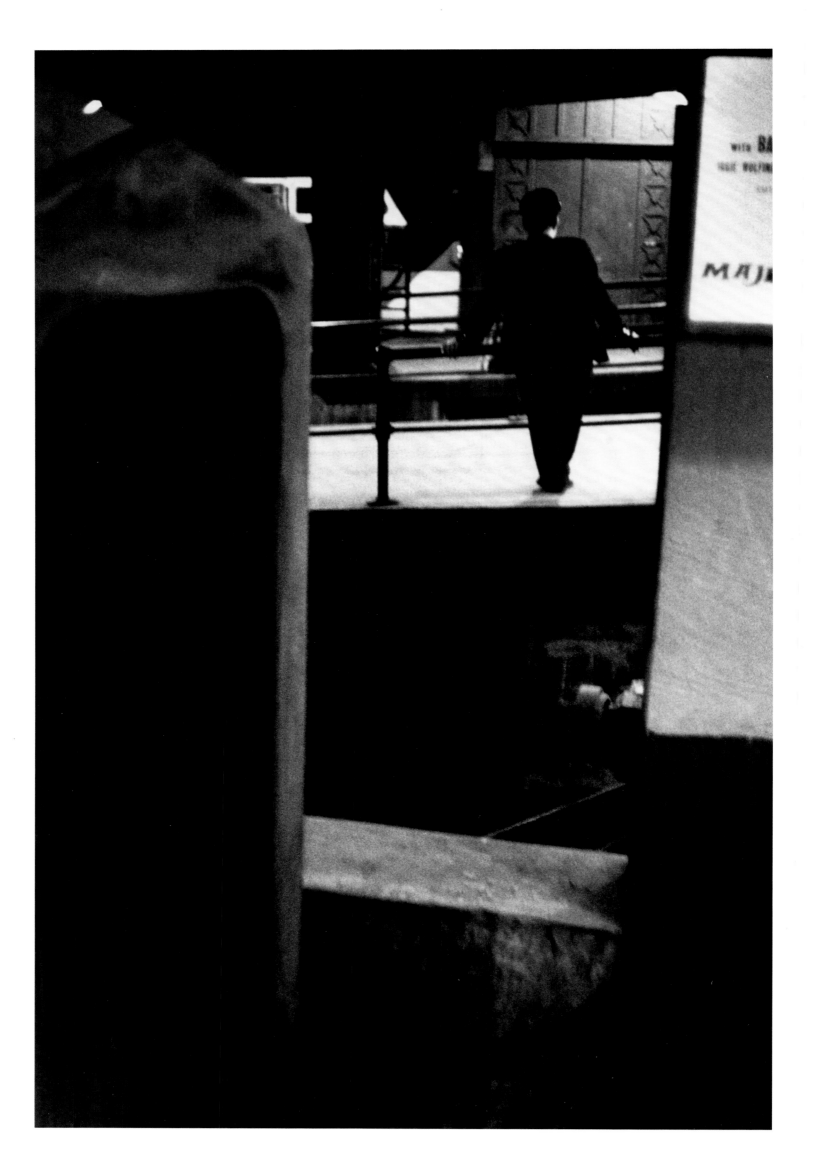

LOUIS STETTNER
PENN STATION, NEW YORK

INTRODUCTION BY ADAM GOPNIK

Thames & Hudson

for Janet

CONTENTS

LOUIS STETTNER'S DELICATE MOMENT

Adam Gopnik

Louis Stettner's photographs from the late 1950s of people in and around New York's long-extinct Penn Station—in trains, waiting in the waiting room, living, being New Yorkers, becoming suburban dwellers—are mesmerizing in ways that are unique, and uniquely difficult to explain. Sure, they are studies of private states in a public place, and so typical of the New York School of photography to which their maker more or less belonged. You see the same kind of imagery in Helen Levitt and Walker Evans and William Klein and the rest. All of them love to show people in the city caught in a moment of reverie.

What makes these pictures unforgettable is that they are studies of *extremely* private states in an *overwhelmingly* public place. In what was then the biggest and noisiest place in town, we find the elegance of absolute solitude. A man sits alone in a bench, waiting for his train to come, and seems as lost in meditation as a penitent in a pew. A porter casually drinks a last cup of coffee while a conductor leans nearby with his cigarettes at hand, indifferent to his own reflection in the luncheonette mirror, the two men seeming as remote from us and isolated from each other as the mysterious people caught in street shadows in the thirties woodcuts of Lynd Ward. Veils make otherwise ordinary men mysterious; simple gates and gratings create uncrossable moats between the spectator and the subject, leaving the solitary waiters enclosed behind as unreachable as Giacometti stick figures. We peer through the brightly lit windows of the trains themselves to see moments of furtive escape—shoes off, stocking feet up—or exhausted absorption: two faceless men reading the evening newspaper, spread out before them on adjoining laps, lined up in mutually secluded sequence. Four more passengers, who have become their Stetson hats—Stettner's Stetsons speak as eloquently of conformity as Manet's opera hats do of dandyism—confer in a crowded, standing-

room-only car, while a boy's shining, skeptical face rises among them like a quizzical flower. Perhaps most unforgettably, a little girl, in her best party dress, dances solo, striding from circle to sunlit circle as they make a perfect pattern across the square-cut floor of the great stone station, light beams leading her on. No one notices her but her, and then, through the photographer, us.

The feeling is both that of a very particular time, the high strange black-and-white moment between the end of the Second World War and the onset of the sixties, a time when America seemed both a triumphant culture, self-satisfied and abundant, and a bulwark culture, full of frightened conformity and silent, midnight rebellions. ("Small Rebellion on Madison" was Salinger's title for his first sketch for *The Catcher in the Rye*, and one can imagine Holden, who put his bags in a locker here, in the corner of any of these photographs, deer-hunter's hat turned round on his head.) The ability to evoke an era is no small one. We say sniffy things about nostalgia, but what is nostalgia save the demotic of memory? It is our way of recalling times past, and deserves the dignity of Mnemosyne. By the same sniffy logic, a Manet café scene is mere nostalgia for Paris in the 1880s.

But there is some other value here, going beyond the era evoked to make these permanent, semi-mystical images of urban isolation and melancholy, to stand alongside not just Levitt and Lynd Ward but Edward Hopper, too. Like all great graphic art they combine beauty and mystery in ways that transcend the simplicity of their formats and the self-evidence of their subject matter. People waiting for trains become symbols of themselves and then symbols of all of us, of anyone waiting for anything, of anyone leaping in light—especially, perhaps, when we do it in a party dress.

"I interpret the world around me according to my vision," Stettner himself explains. Now ninety plus, and living for a long time in the immediate Paris suburb of Saint-Ouen, where the flea market is, he is a model of modesty who still has a keen sense of his own worth and how his pictures got made back in 1957 and '58.

"The first one was the girl walking in sunlight on the floor," he explains, startling the listener with the news that what is, in many ways, the masterpiece of the series was its initial instance. "A year later, I started on the whole experience. The man at the station smiled and gave me permission. No one ever objected to my taking pictures—it was after the war; people were getting into enjoying peace. There was bonhomie, a

8

wonderful spirit, a comradeship everywhere. It was a rare communion between the subject matter and me. Well, it helped I was in the dark."

Stettner's elaborate shrug is typical of the masters of his form and kind. Photographers tend, vocationally, to understate the intellectual preparation necessary to their work, as other visual artists tend to overstate theirs. The myth of accident—I was there, that's what I saw, you would have seen the same—remains essential to the form, in part because the element of serendipity really is essential to its beauty: if we try to make photographs too artful, we miss what makes them art. (In conversation, he emphasizes simply the camera he used and the film that went into it: "I used a Leica M3—and let me say this: it would be impossible to do those same pictures today. I print all my own work, and the shadows were alive—all the shadows have powerful nuances that they don't even try for today.")

But though Stettner disclaims any premeditated intention for his Penn Station photographs, he is, for all his sense of the ease of that time and place, also very shrewd about the larger social change they document, in a way that is a useful corrective to a too-neatly "universalized" appreciation of their imagery. These images of Penn Station at the end of the 1950s are about ascent in social class. "Look at them: they're all dressed the same—from a class point of view it's the working class going to the lower middle class. In a way, that's the subject—these people at Penn Station were all taking on all the attributes of the new class: dressed the same; reading the same newspaper; headed back and forth from the same kind of houses in the suburbs. Standardized dressing was a way of life. If there's a melancholy in the photographs—and people tell me there is—maybe it's that they were tired of the effort. You know, these are mostly morning trains. They all wore hats. In that time, you could always tell the work someone did by how he or she dressed. These aren't working people by any means. They're the office working classes. And that was the new class in the country. The conformity gave them more status. What struck me always was that they seldom talked to each other— except for people playing cards. They all read the *New York Times* silently."

The ascension in social class that Stettner mentions also marks out a different task for photography than the one the New York School had attempted in the forties. In the work of Evans and Levitt and the rest it seems not unfair—for all that they are highly individual artists with their liquid agendas of highly individual artists—to see their ambition as essentially realist in the original sense: to show the hard lives and

small pleasures of those too easily overlooked. They are real about those not granted a sufficient place in reality. When we see Helen Levitt's magical image of children chasing a makeshift itinerant merry-go-round on a street in the West Forties, we sense, and are meant to sense, something about the hardscrabble pursuit and relative rarity of any pleasure in these children's lives. Stettner, in the late fifties, though working in an extension of the same documentary style, is doing something else. The comfort of his subjects, their access to material pleasure, is never in question, whether the life they've found themselves in—this new life of social ascension into the "new class"—is worth the effort in conformity and exhaustion that it always demands. In a larger sense, this was the great question of its day, one that in our own era—newly alert to inequality and the apparent destruction of middle-class prosperity and, with it, of the public spaces where American middle-class lives used to typically play out—we can easily miss. Visit the bookstore in the station during Stettner's era and one would have found countless books, in sociology, poetry, criticism, and the novel, that perfectly complement Stettner's vision. *Growing Up Absurd, A Sad Heart at the Supermarket, The Organization Man*—even the literature of romantic excess, as in Mailer or Kerouac or Thomas Merton, found its energy from its oppositions and took for granted the civilization of ever-growing (if ever more plasticized) abundance that sheltered it.

The authors of the fifties and early sixties all saw a society almost too much at ease with itself. In a strange way, these images, which we look back on with that often-criticized nostalgia, were in their day much bleaker documents than they are now. We see in these faces an order passed; their day saw in them an order imposed. This is the other, poetic side of the fifties literature of conformity, order and its discontents: moments of work have their delight, too. The small girl dancing her way across the station floor has her cognates, too, in the small moments of unexpected epiphany that fill Salinger's writing and create its positive opposing pole to the phoniness, the emptiness, that drive his New York characters to suicide and New Hampshire. The girl in Penn Station is the cousin, or sister, of her exact contemporary, the girl on Park Avenue who loses and finds her dachshund in *Franny and Zooey*. Stettner's Penn Station pictures are not an art of protest, God knows (and be thanked), but they are witnesses to lives about which protest is still possible, because they do not protest enough on their own behalf. A pair of stocking feet is the only silent protest against the corporate shackles on the businessman's shoes.

Looking at Stettner's pictures, we can't help but think about the lives that his people led and the public place they led them in. Stettner today says that the thought of losing Penn Station seemed then, in 1958, almost unimaginable. Penn Station was as permanent and uncontroversial as the Hudson River its trains superintended. "What attracted me most was that this was a place that gave dignity to people. A place where you felt you were living in a better world. It was marble and iron and very graceful, a place with high ceilings that enforced the dignity of the human race—a place where you felt more worthy than on the street. You felt good there. There was a romantic excitement about trains—Pullmans going to Washington or California. It was a whole ritual there—porters dressed up in uniforms, and the people entering the trains, slow and graceful."

Inevitably, without reducing his pictures to the place where they were made, it is still hard not to protest the loss of such places. To imagine a modern Stettner either in the new Penn Station or in its closer equivalent, the modern airport, Newark or JFK, is to see a diminishment. Pretty much the only subject one can find in the airport is not isolation but its near neighbor, exhaustion. In Penn Station, exhaustion is turned into a kind of elegance; in Newark airport, even an effort at elegance becomes another kind of exhaustion. No places have ever been so dispiritingly designed as machines for draining people of color and charm as the modern airport.

The degradation—or perhaps one should say the commercialization—of public spaces is a feature of our time, of which Stettner's photographs act as reminders. It is part of the necessary heart discipline of every modern person not to allow too much longing for times past to pollute her heart. If you did, you couldn't stand it. But there really are losses in the world. Our trading magnificent public spaces for mean ones is one of them. Mean places drain men of their dignity, and liberal societies depend on amplifying the dignity of individuals. It is why our most successful, triumphant building types are not memorial spaces—royalist and reactionary societies do much better mausoleums and triumphant arches—but meeting spaces: train stations and museums and big taverns and the ground floors of department stores, with their elevators and Eagles. Diminish those, and we diminish ourselves. The loss of Penn Station implies the loss, in every sense, of these people's place.

But finally, all of these echoes, however truly they ring in these pictures—echoes of a lost time, echoes of changing classes, the reverberation of the loss of great public

architecture—can't conceal the truest bell that sounds when we look at these photographs, and that is the bell of the one right person caught in the single telling moment. Cartier-Bresson, whom Richard Avedon once called the Tolstoy of photography, is famous for having sought and found in his photographs the "decisive moment," the moment of maximum drama in ordinary life. Stettner, working in his own precinct, searches instead for the *delicate* moment, the moment of maximum inwardness and deliberation, of inner delay. The woman sitting alone on the bench—Is she a waiter or a boarder? Does she know? The little girl perched up like a suitcase on the luggage-weighing platform? Does she remember the joke? Was it a joke, or merely the worn-out mother's convenience? These are what used to be called anecdotal, or personal, questions, and were once thought not suitable material for art. But art is about persons, and Stettner makes them his material, which is what artists do.

Little wonder that these photographs, which had no commercial home when they were made, are now so entirely at home in our heads that they rarely leave them. Stettner now recalls ruefully that "After I got through, I submitted them to *Life* magazine—I used to freelance for *Life* magazine. They didn't want them. Nobody wanted them. They were too present, it didn't strike anyone as unusual enough—it wasn't newsworthy. It wasn't sexy. Nothing happened. It was just, you know, whatever, Sunday. It was just people in Penn Station." It still is. They still are.

PENN STATION, NEW YORK

Note: All but one of the photographs in the series reproduced here were taken in 1958; the photograph on page 17 was taken in 1957.

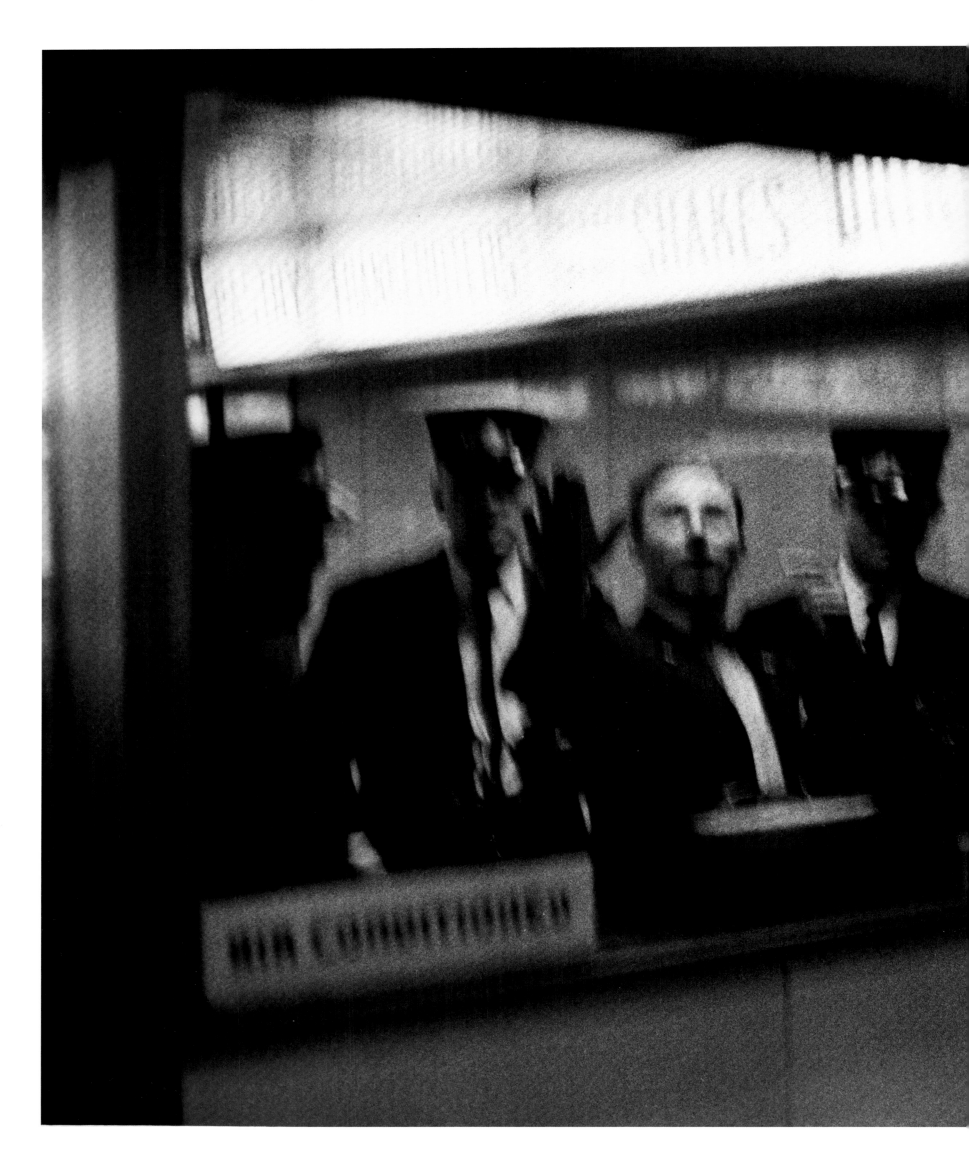

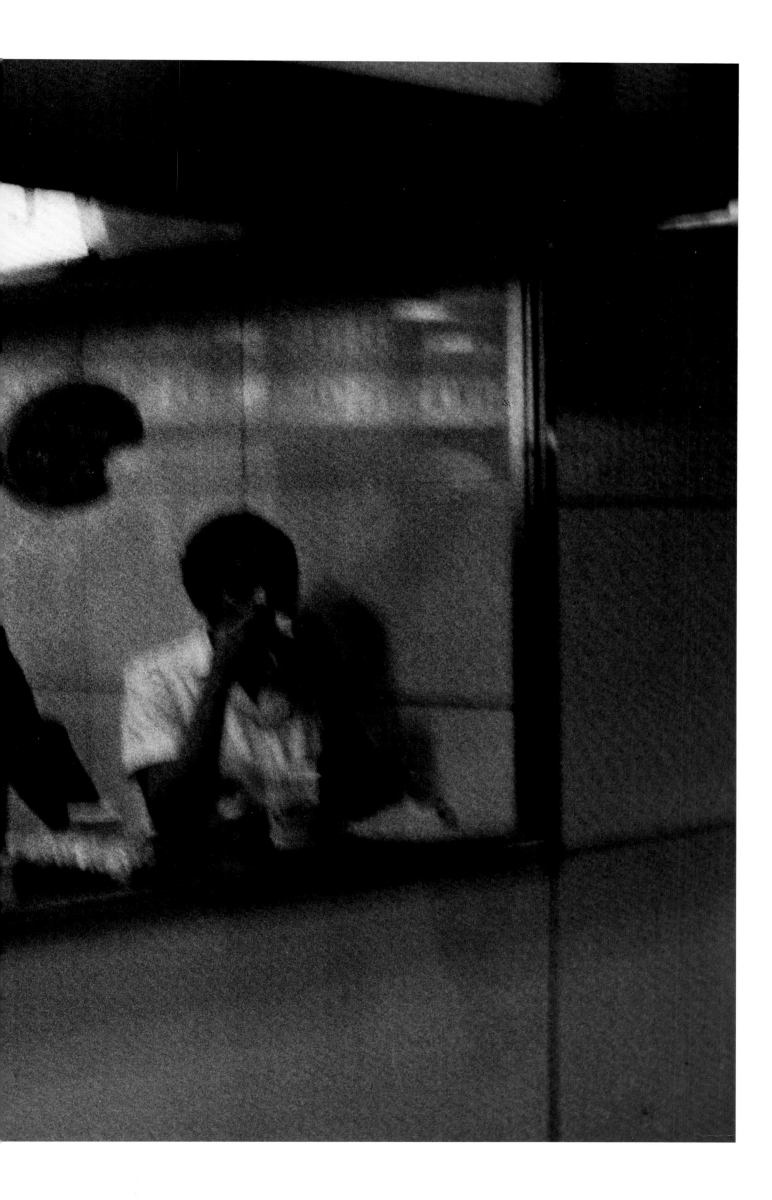

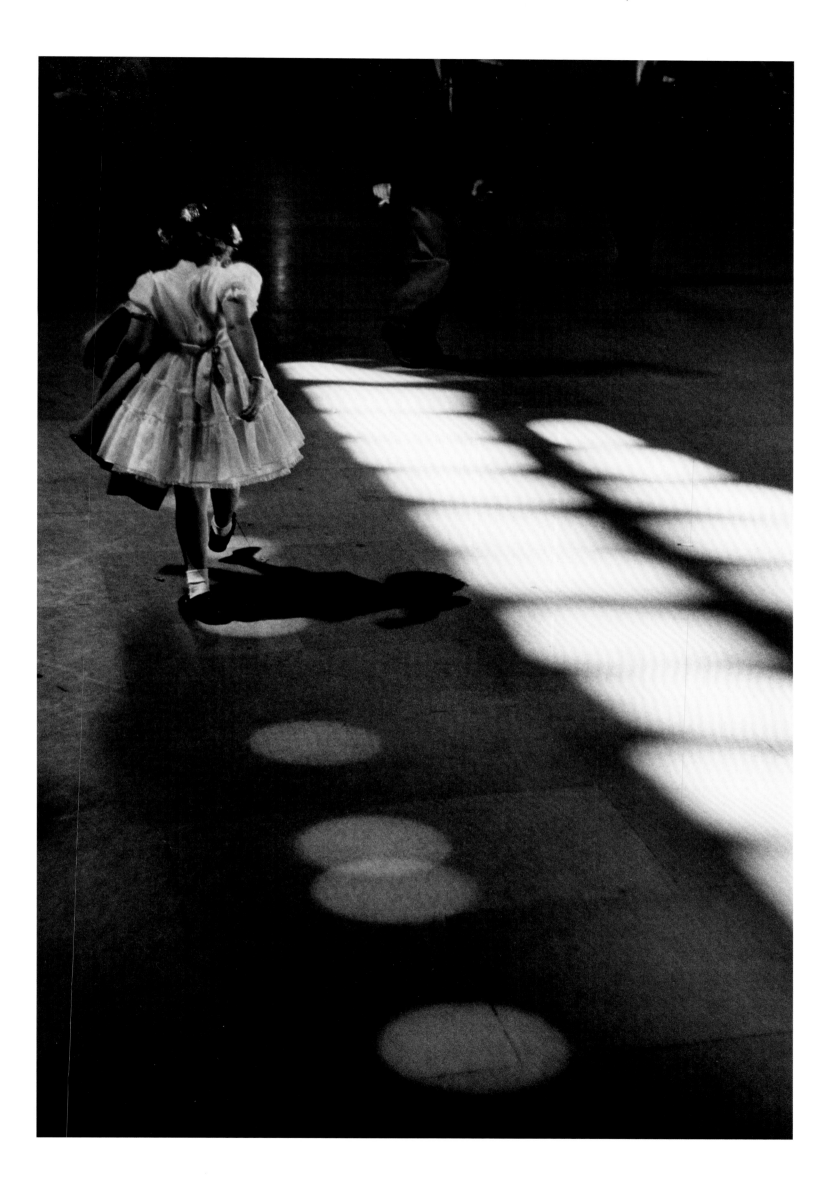

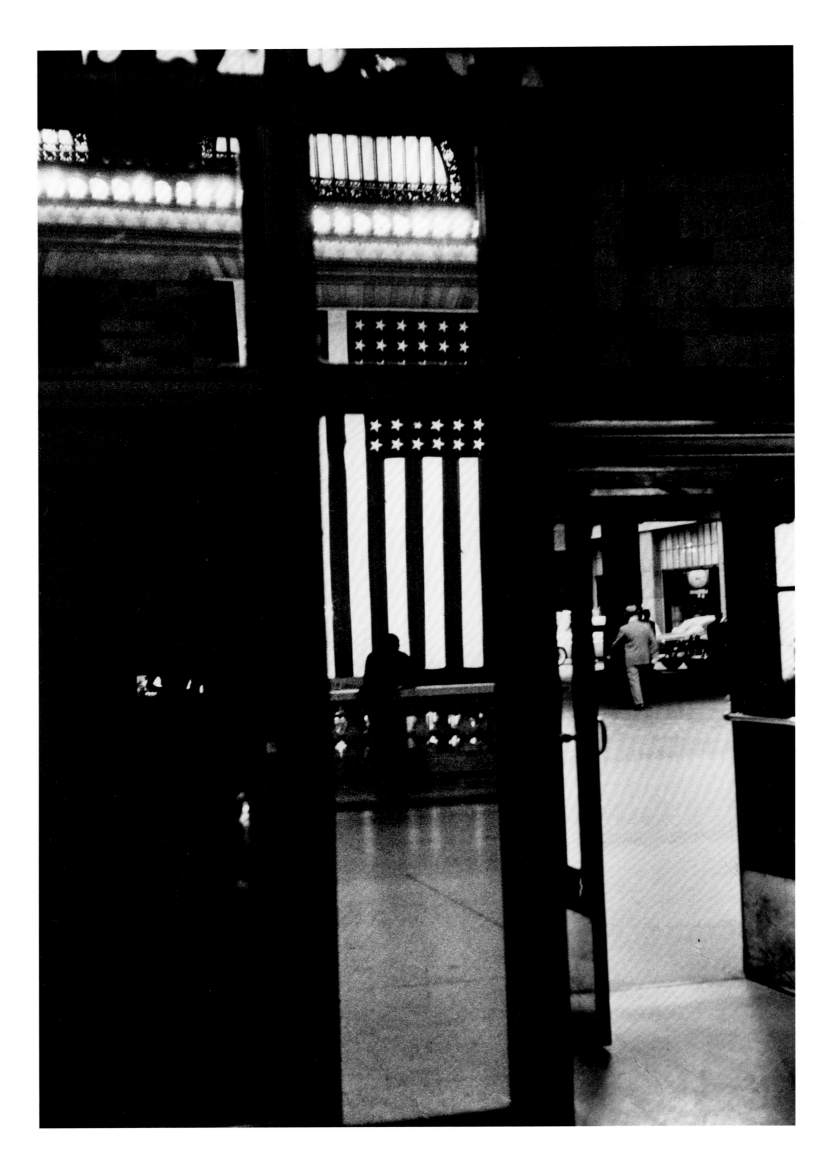

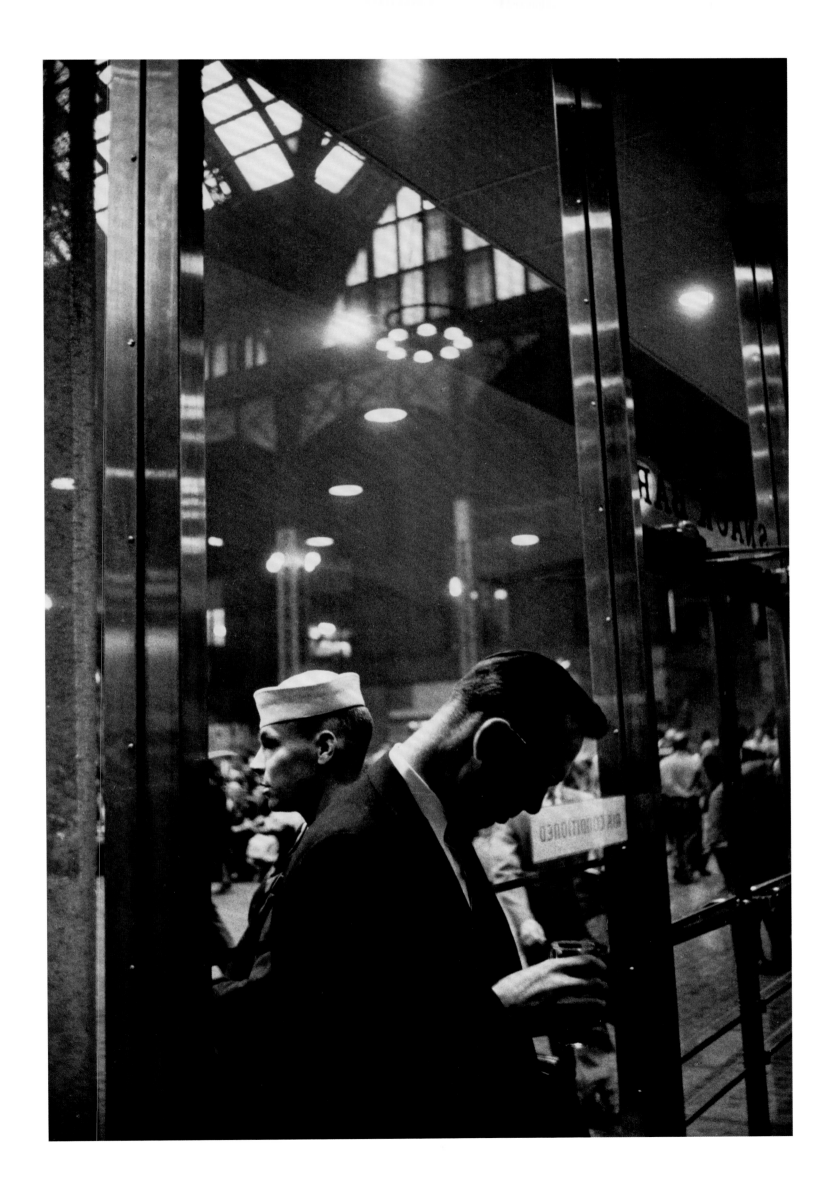

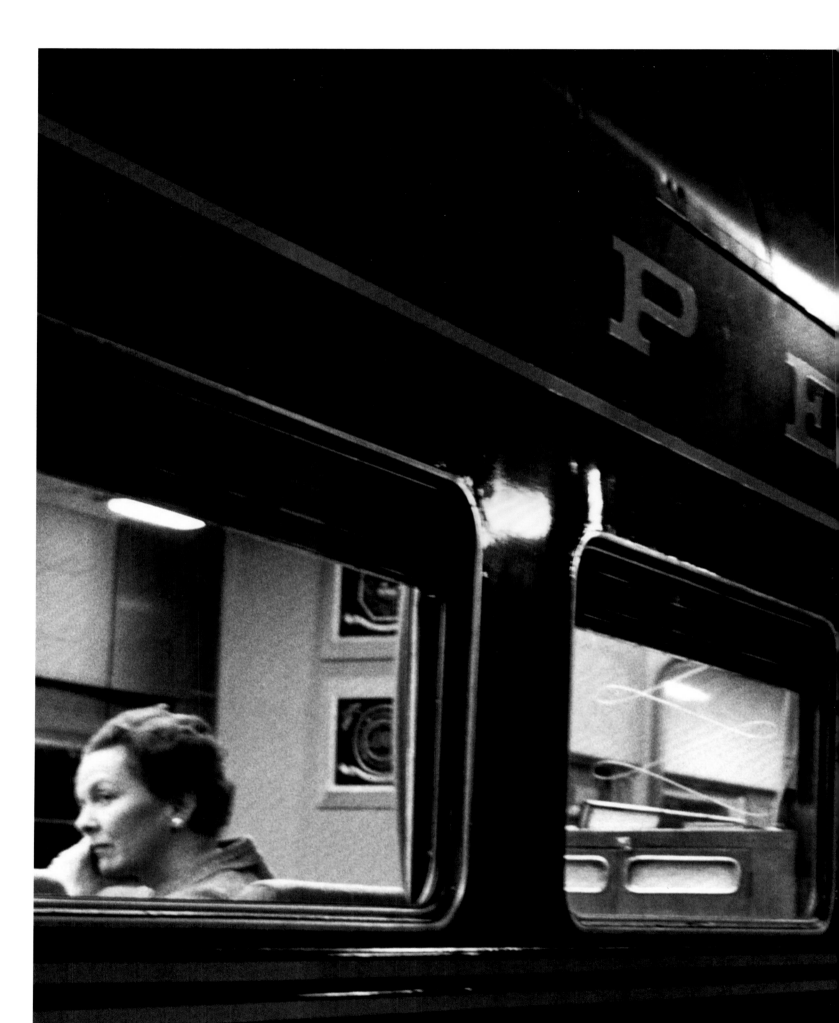

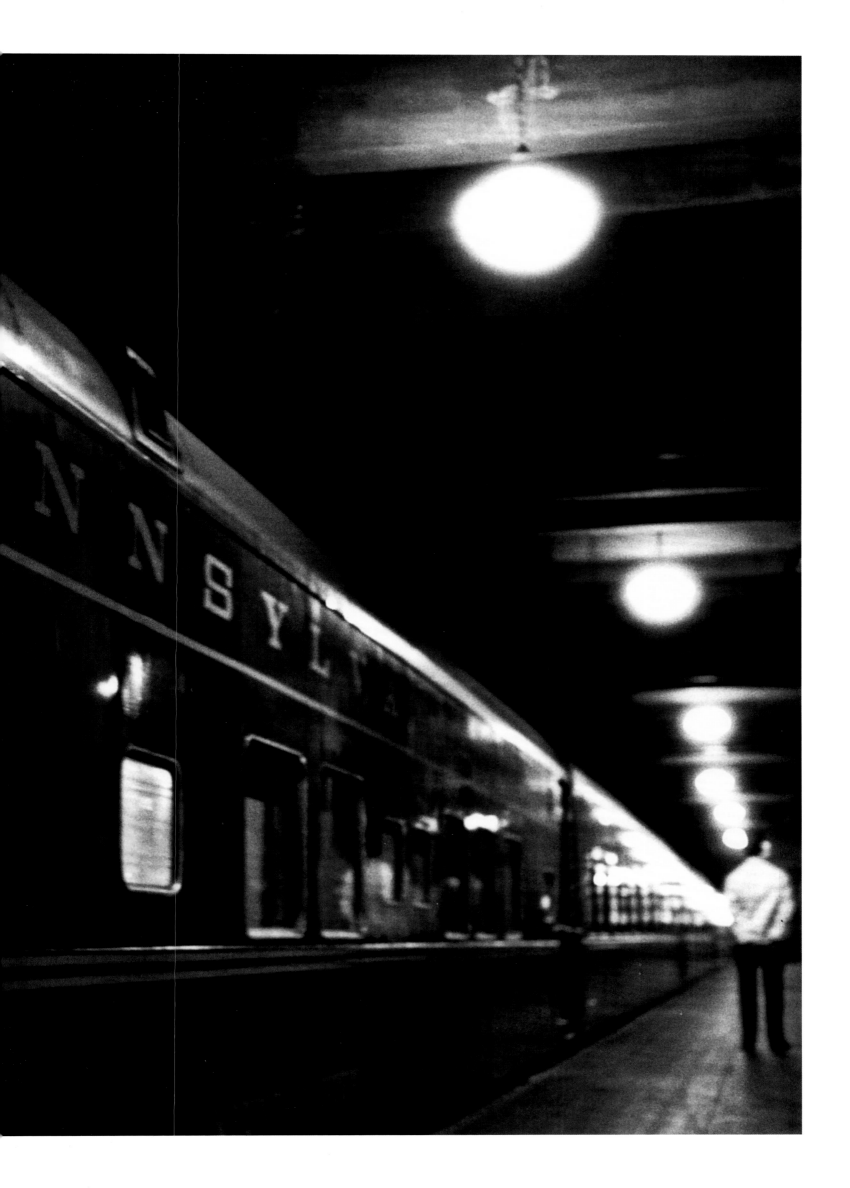

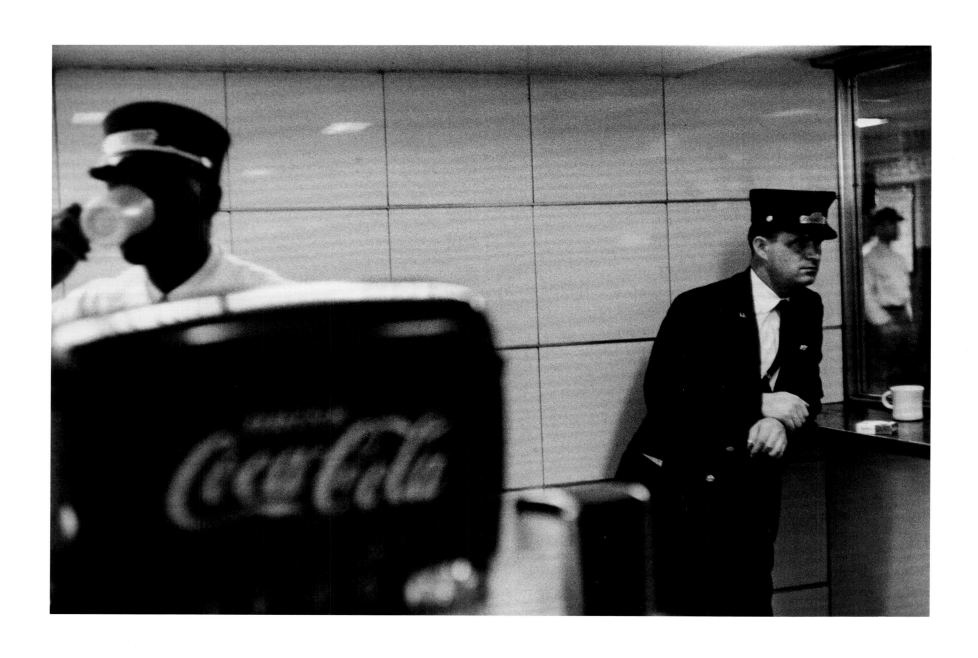

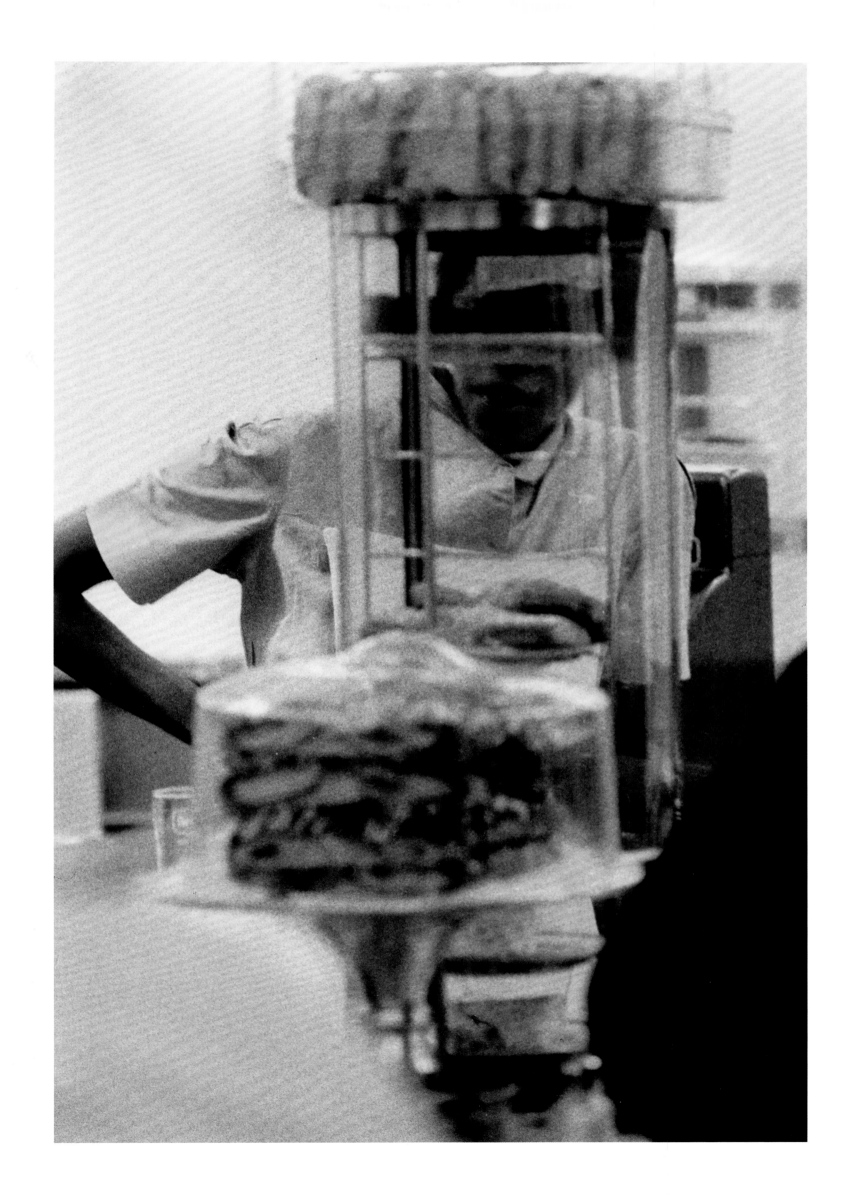

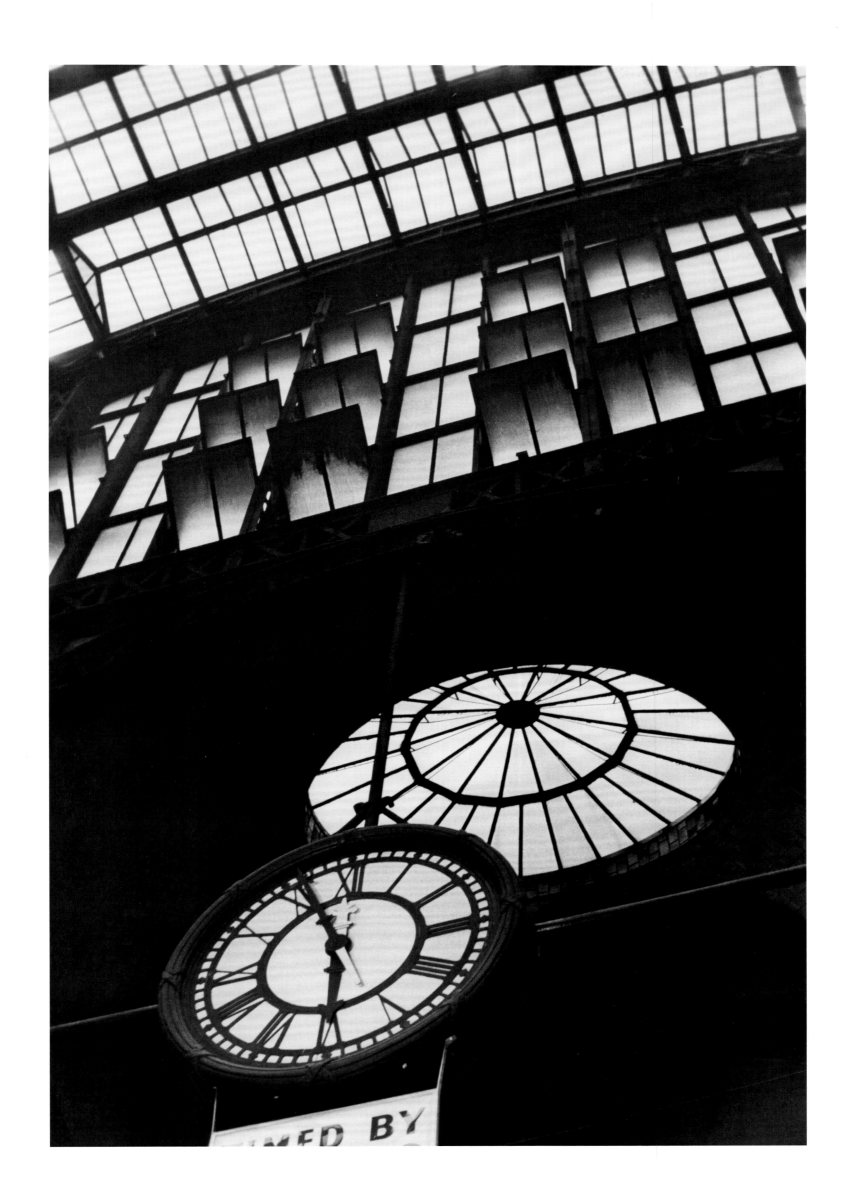

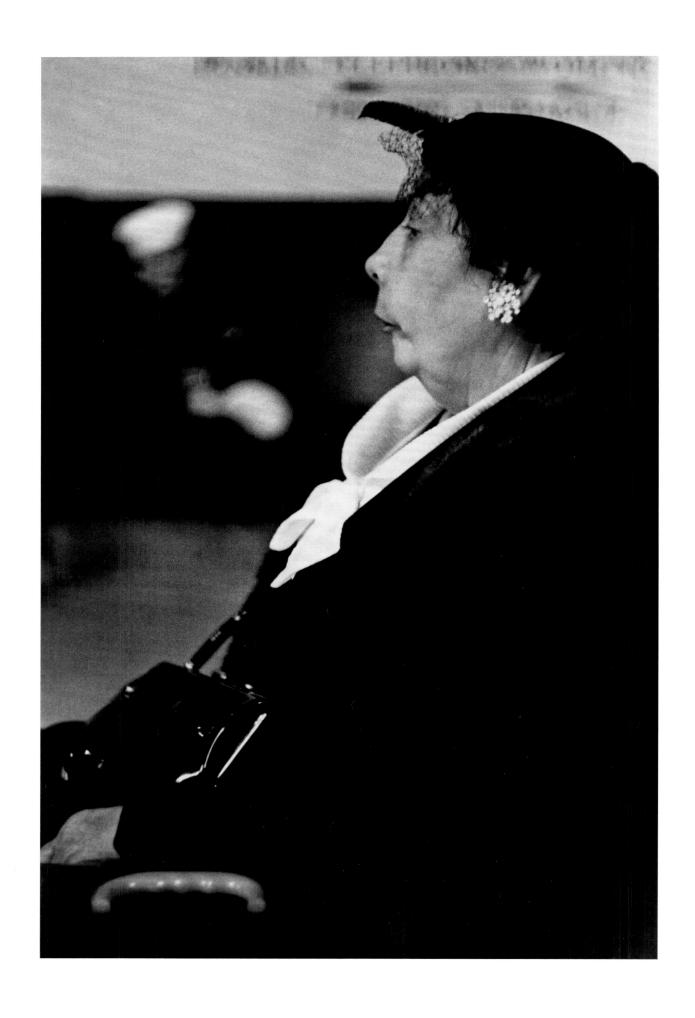

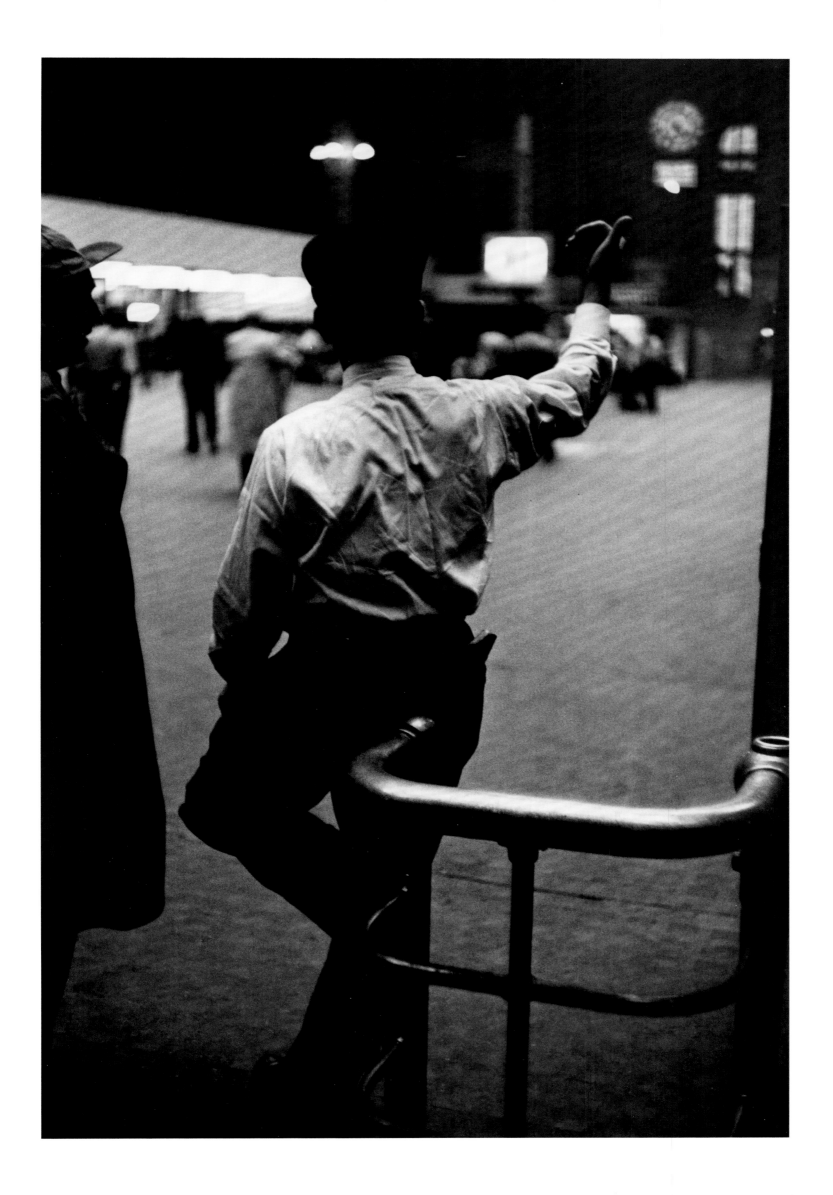

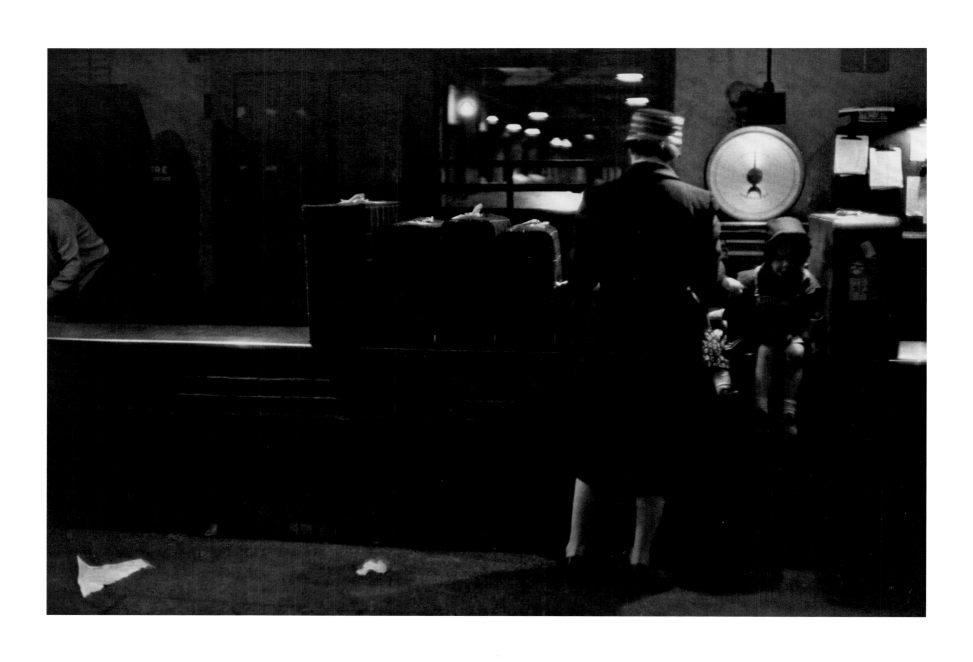

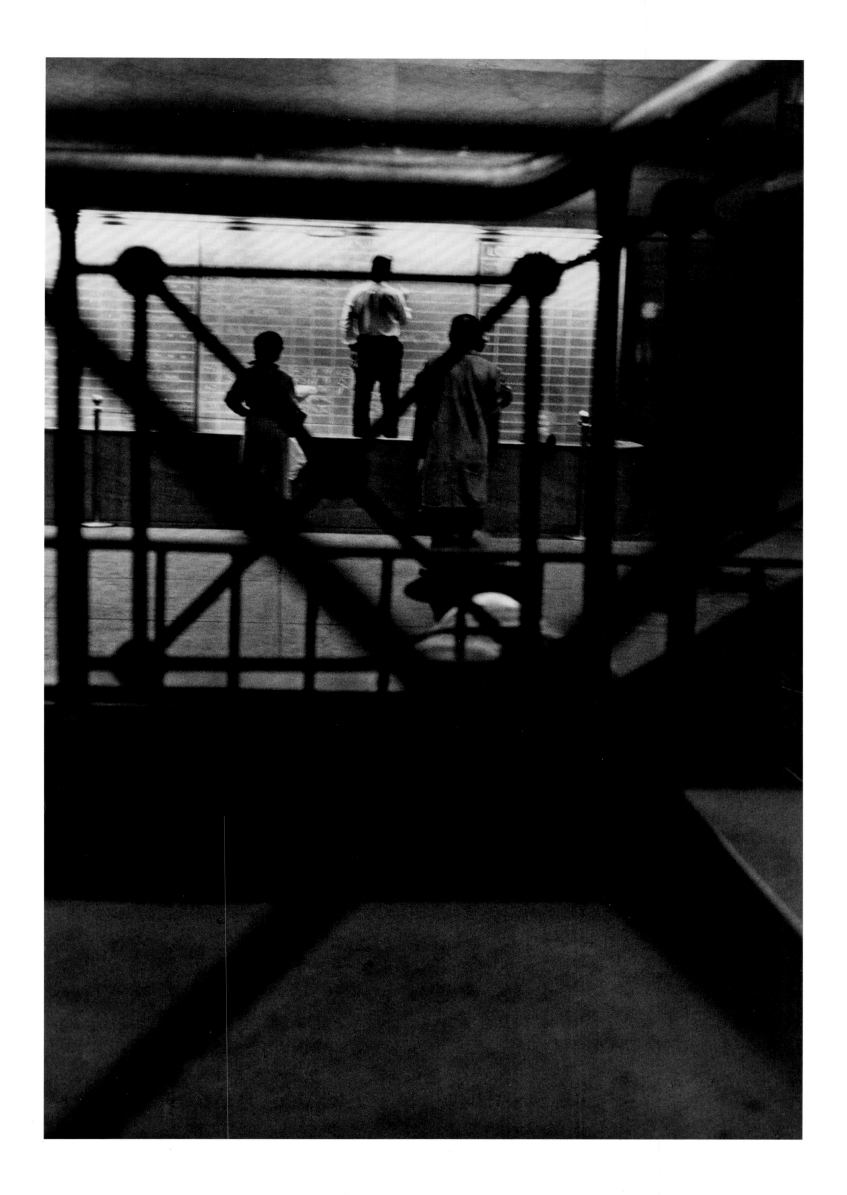

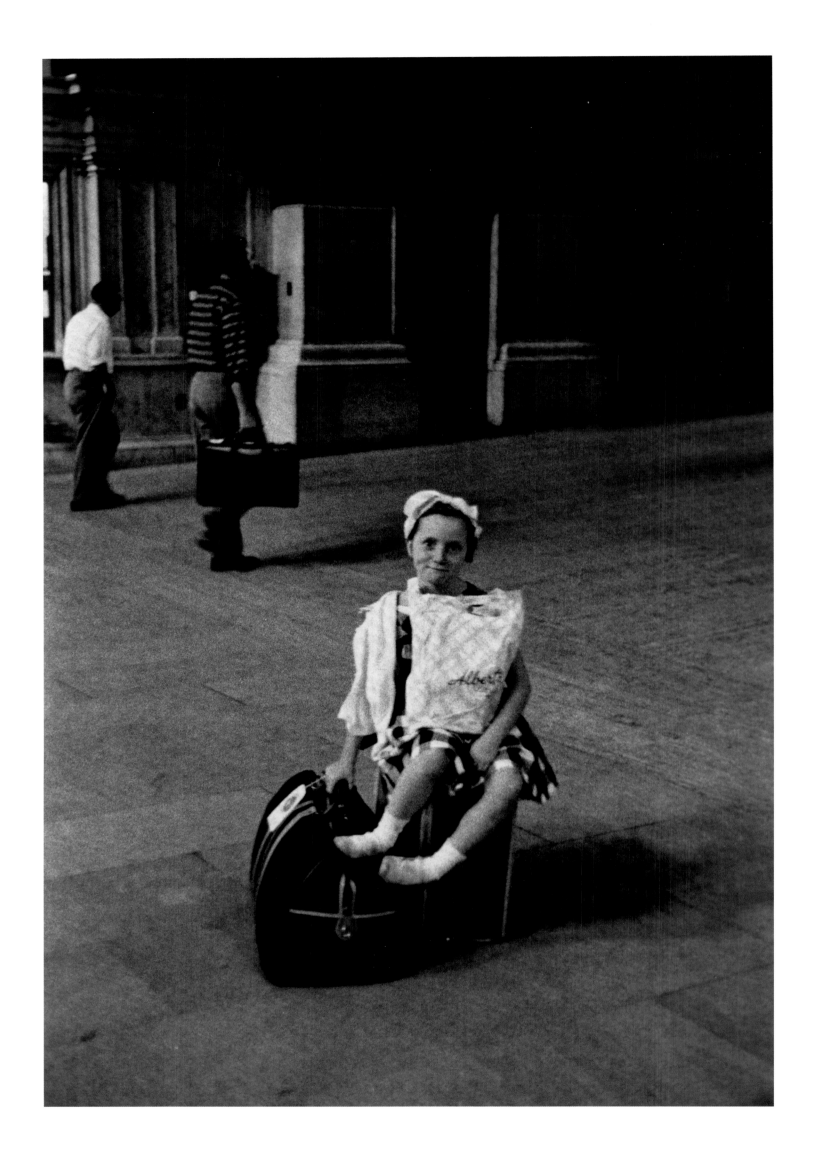

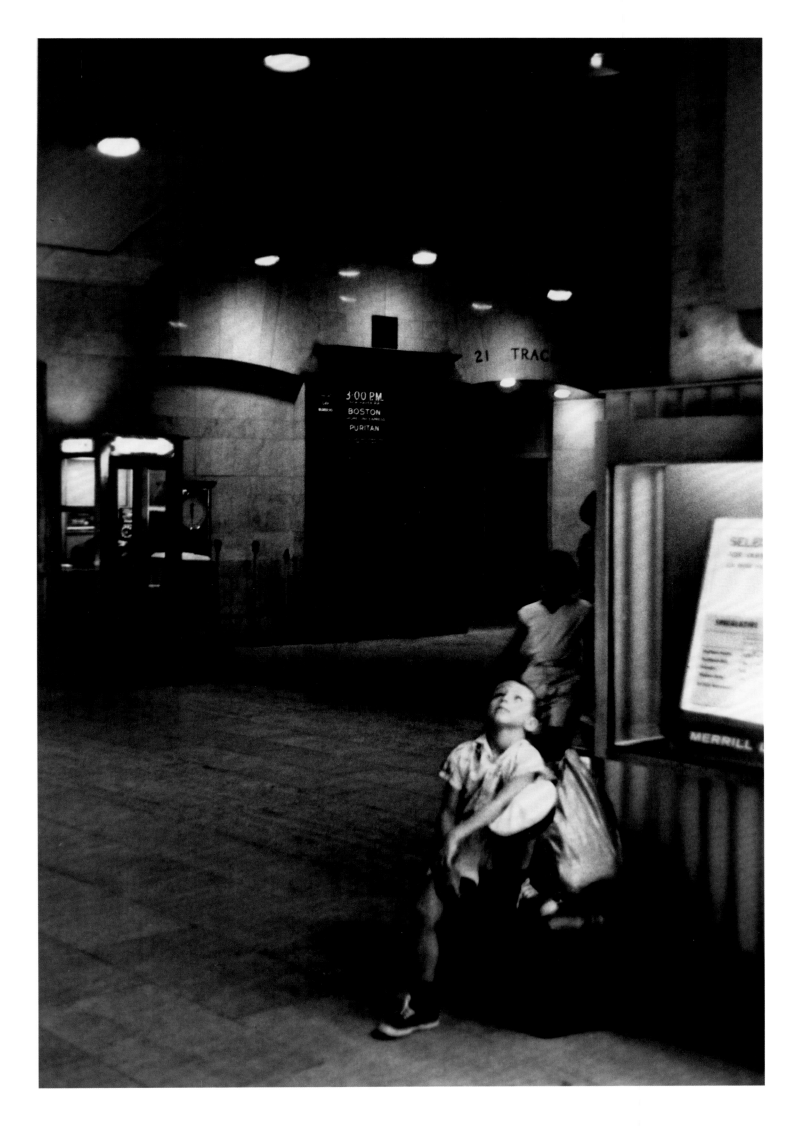

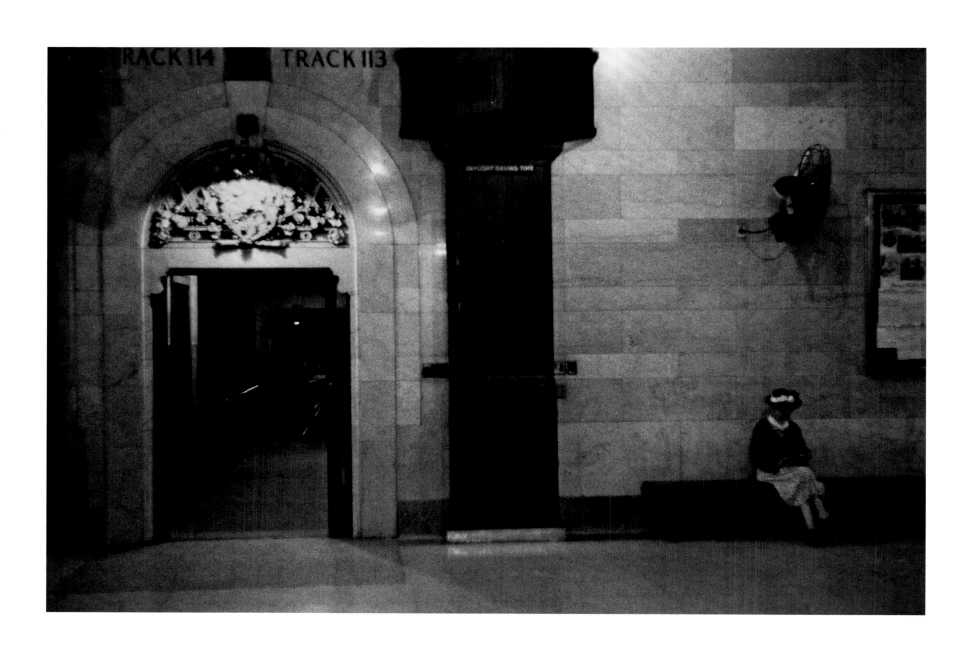

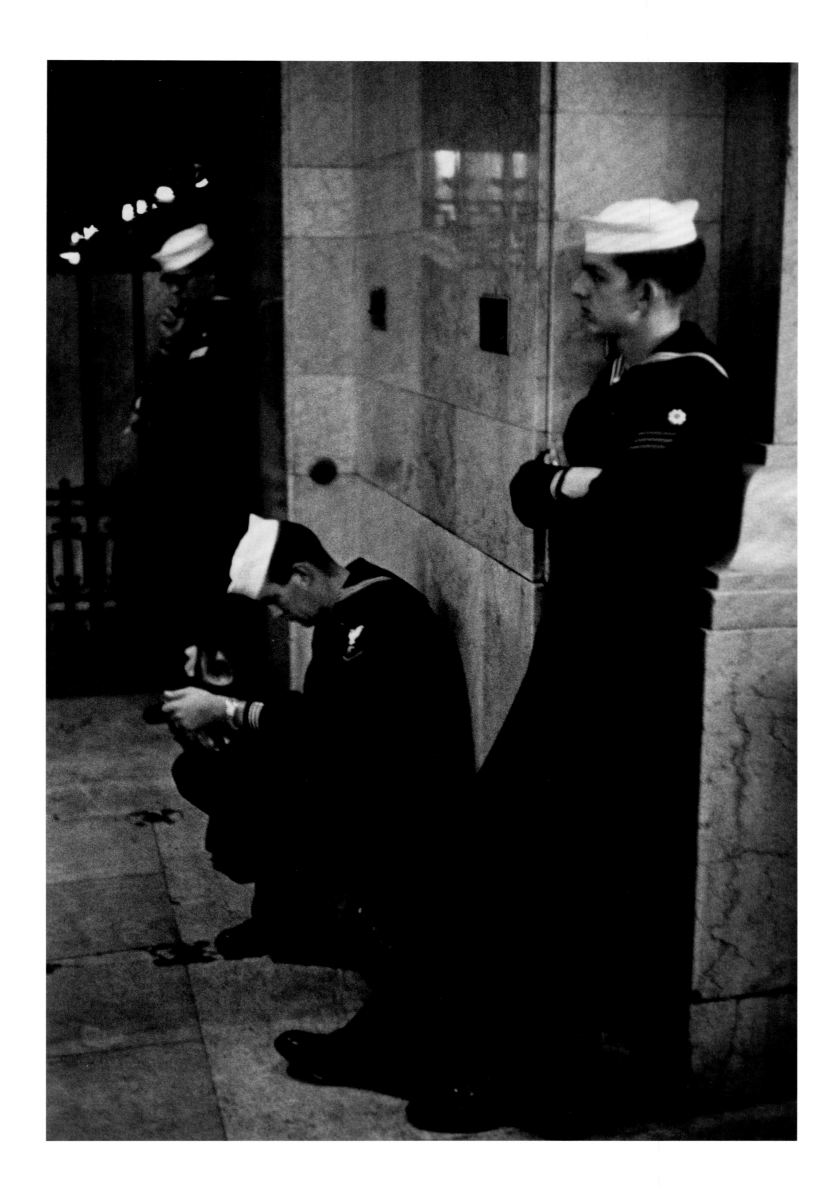

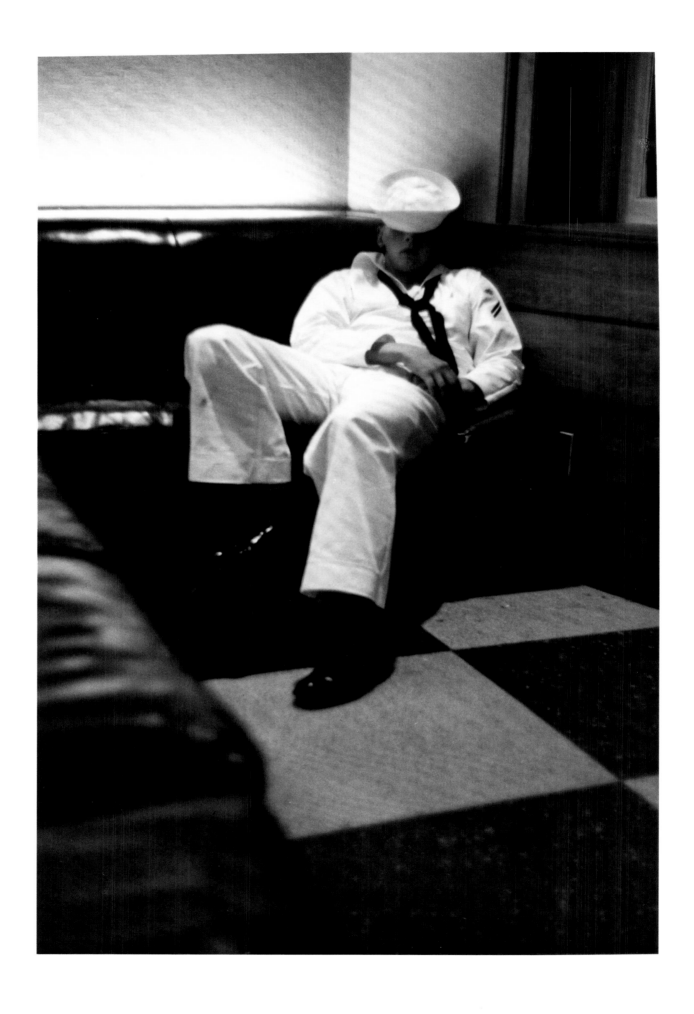

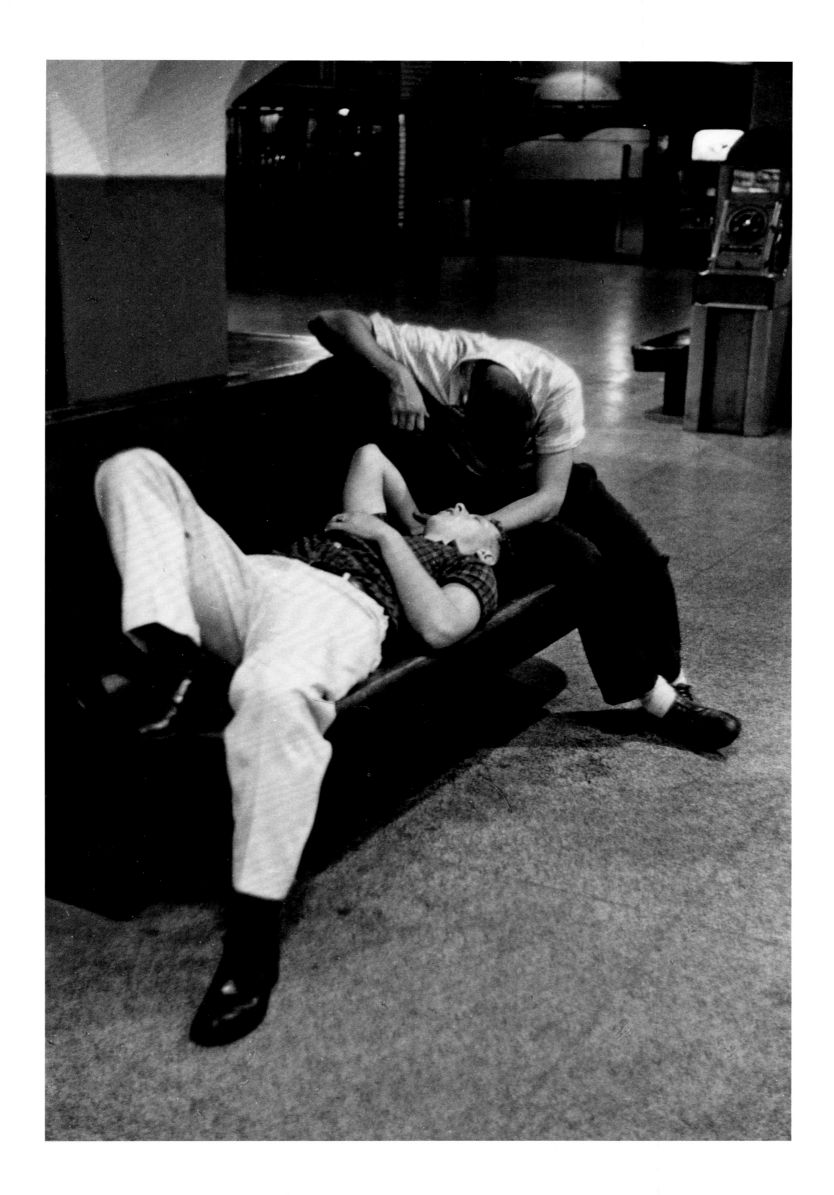

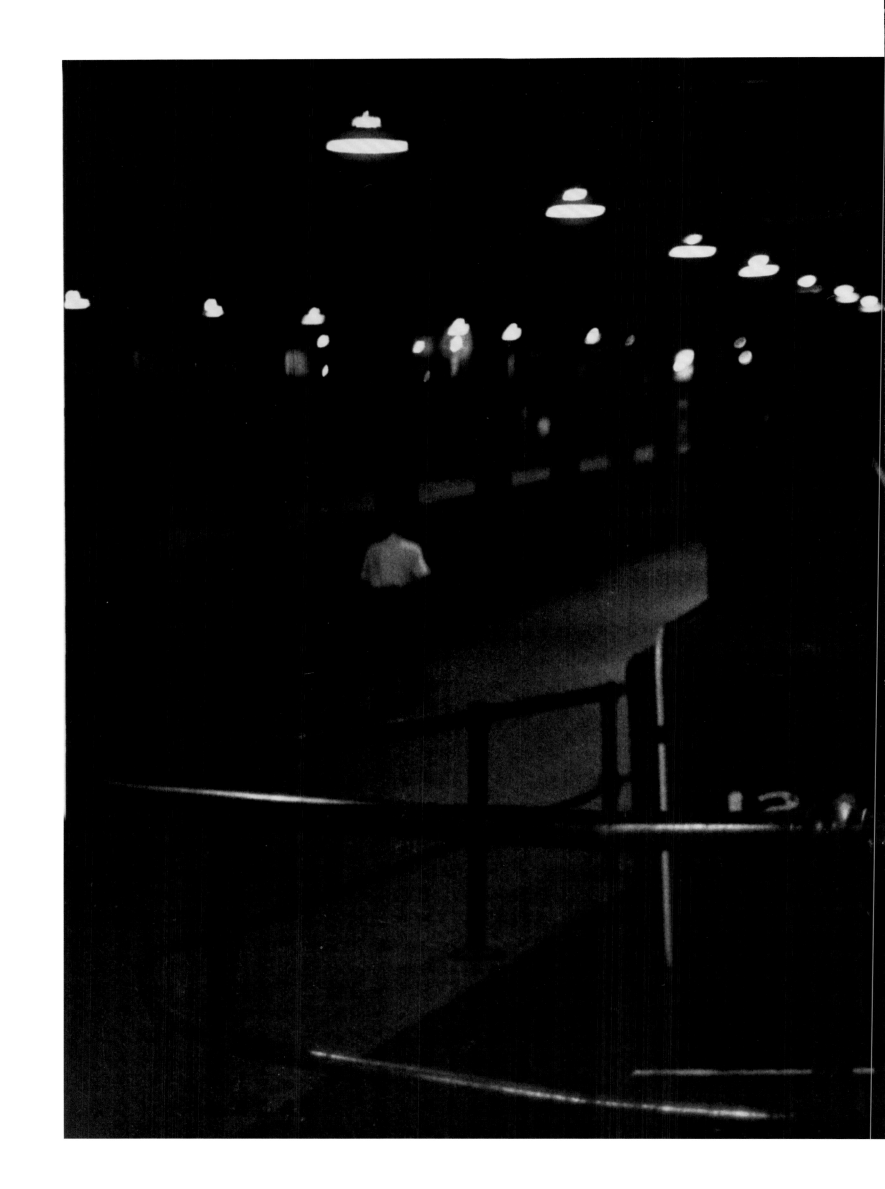

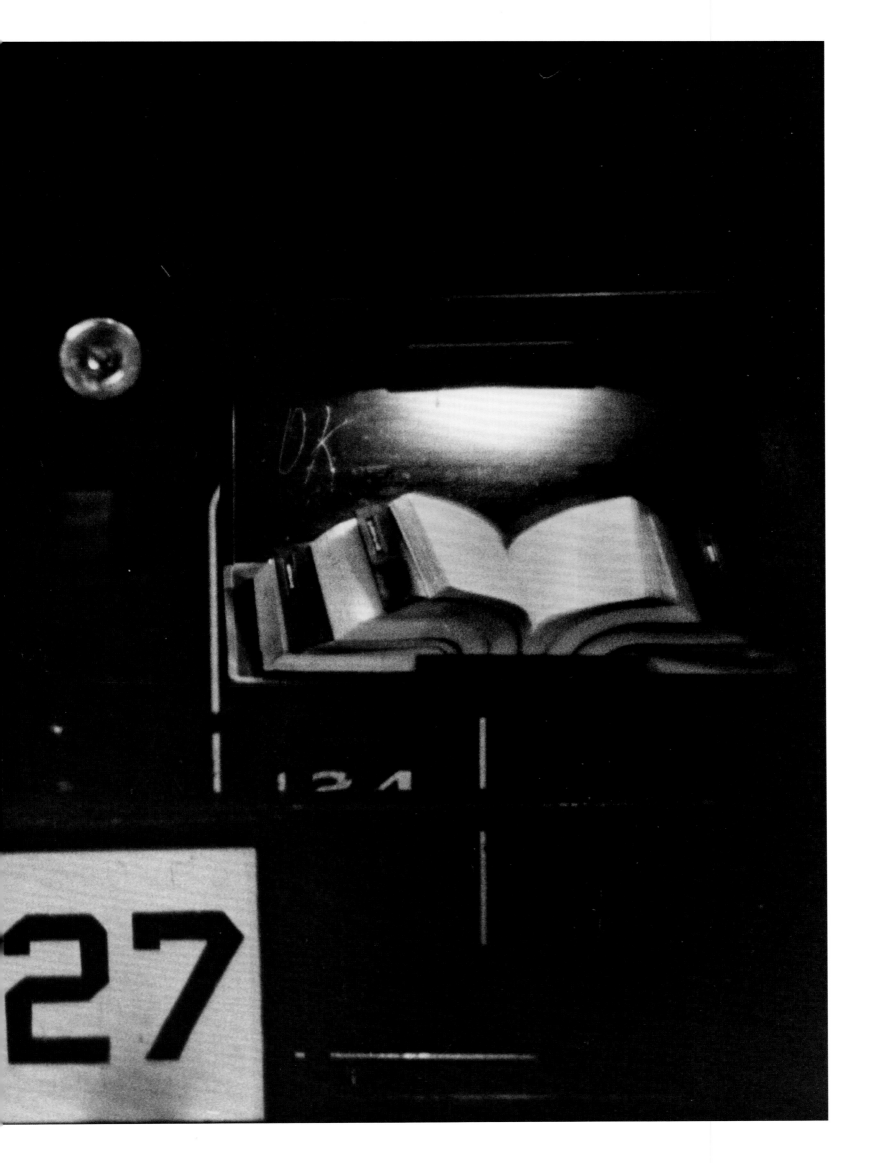

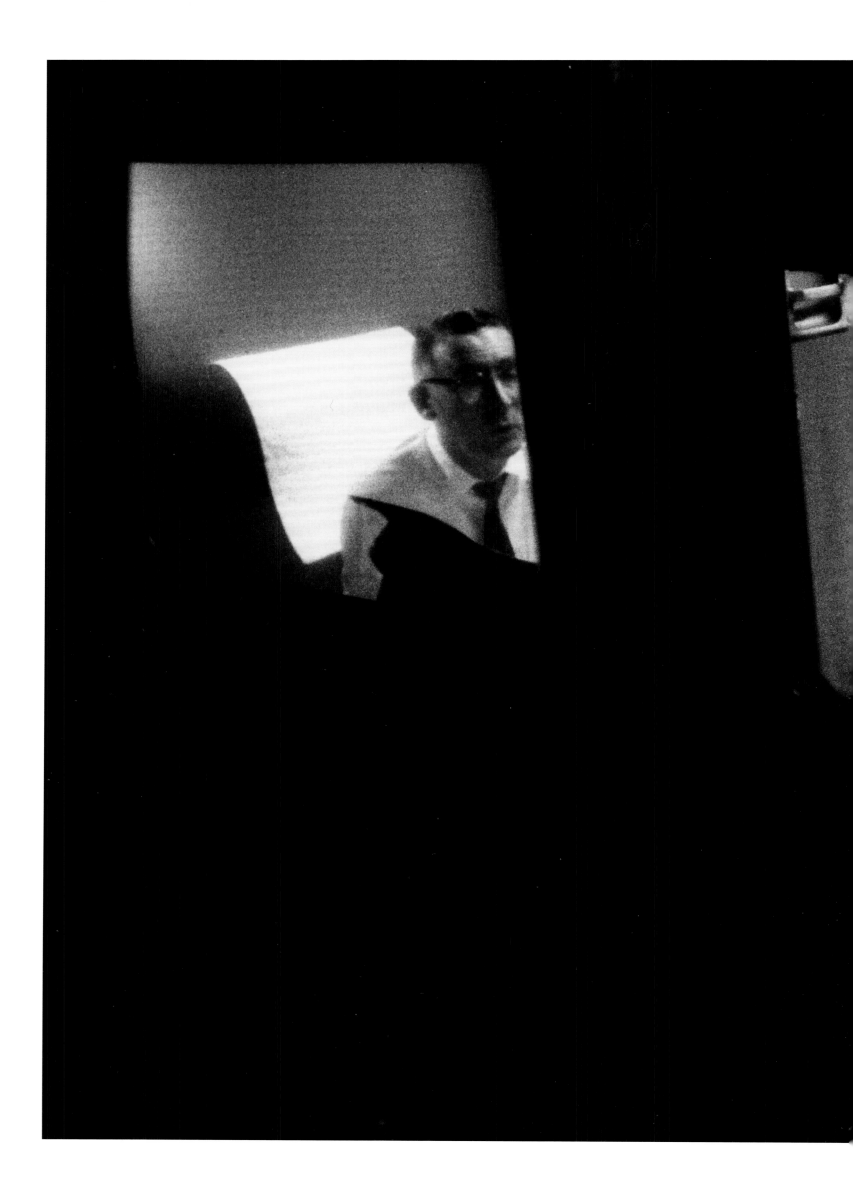

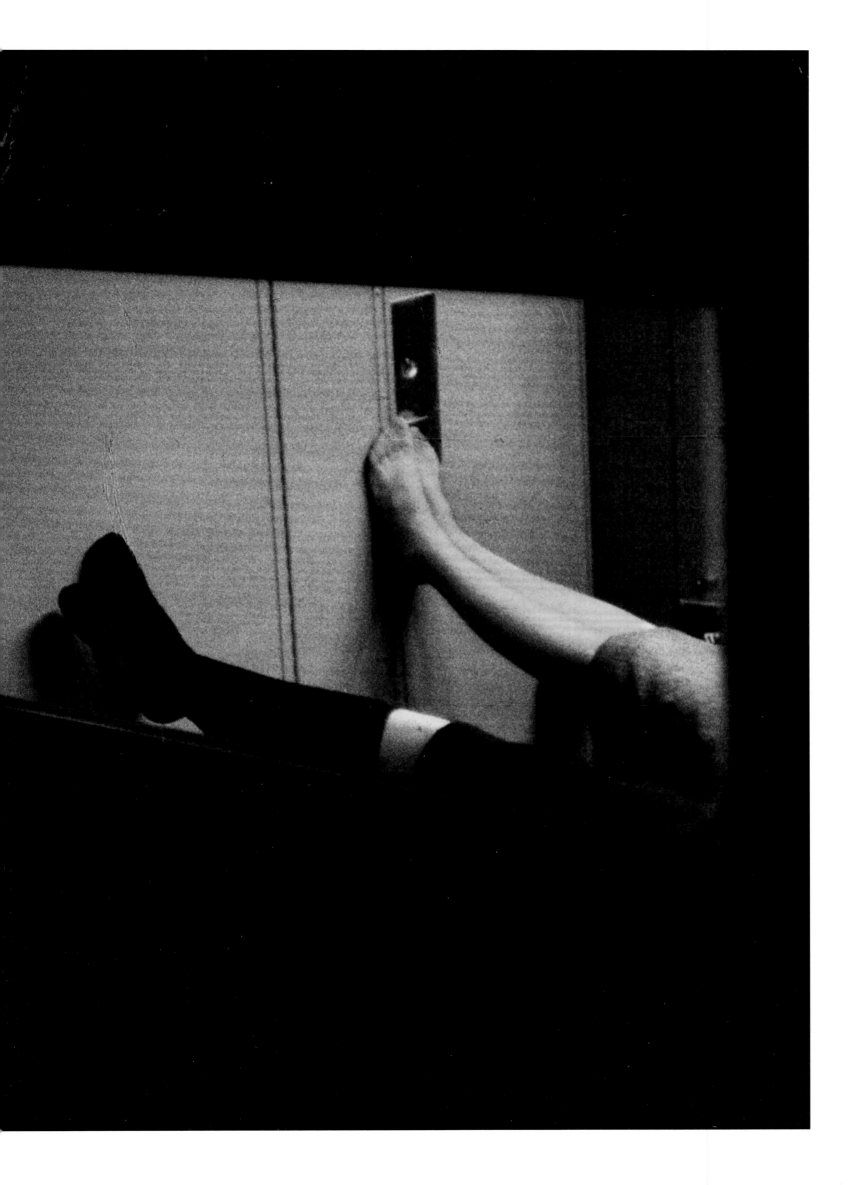

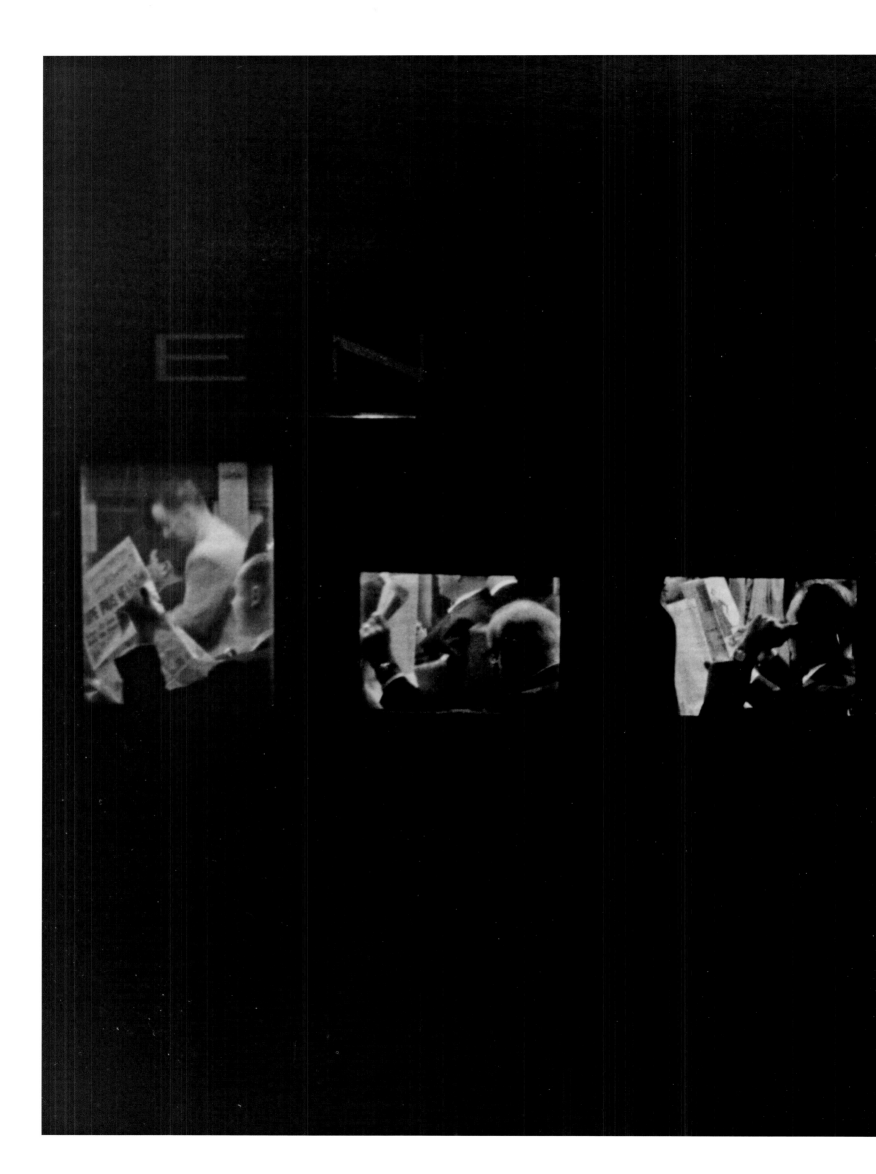

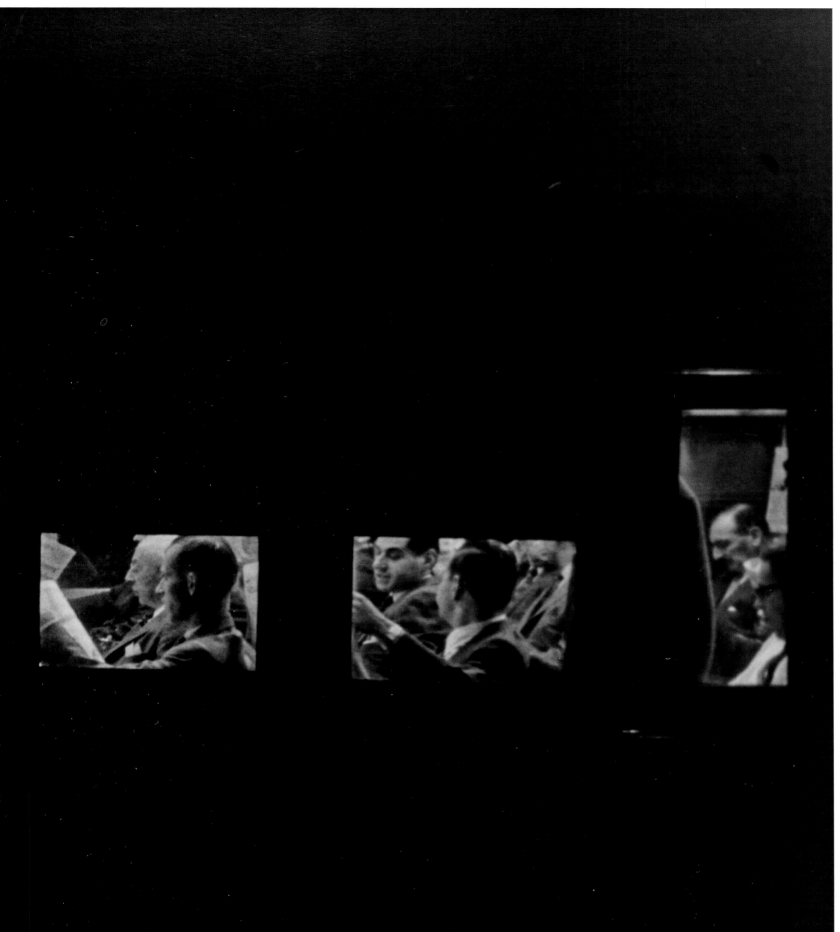

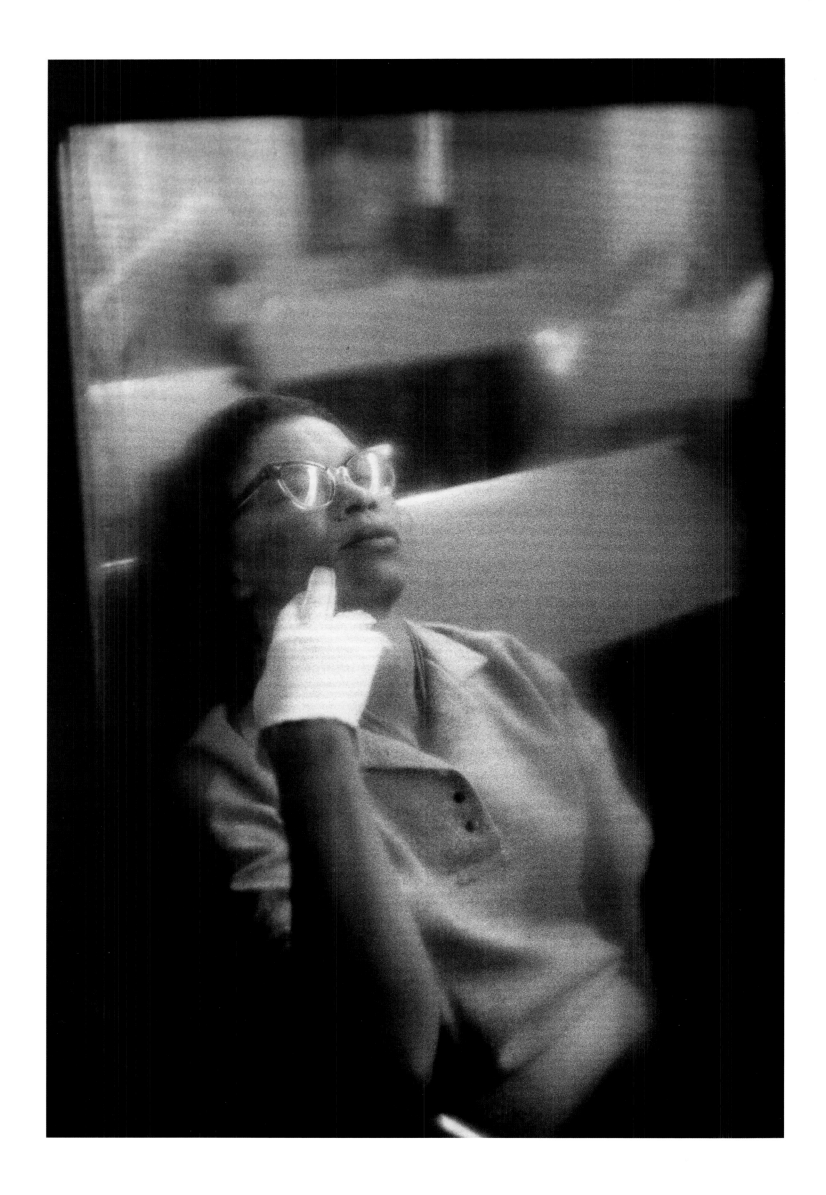

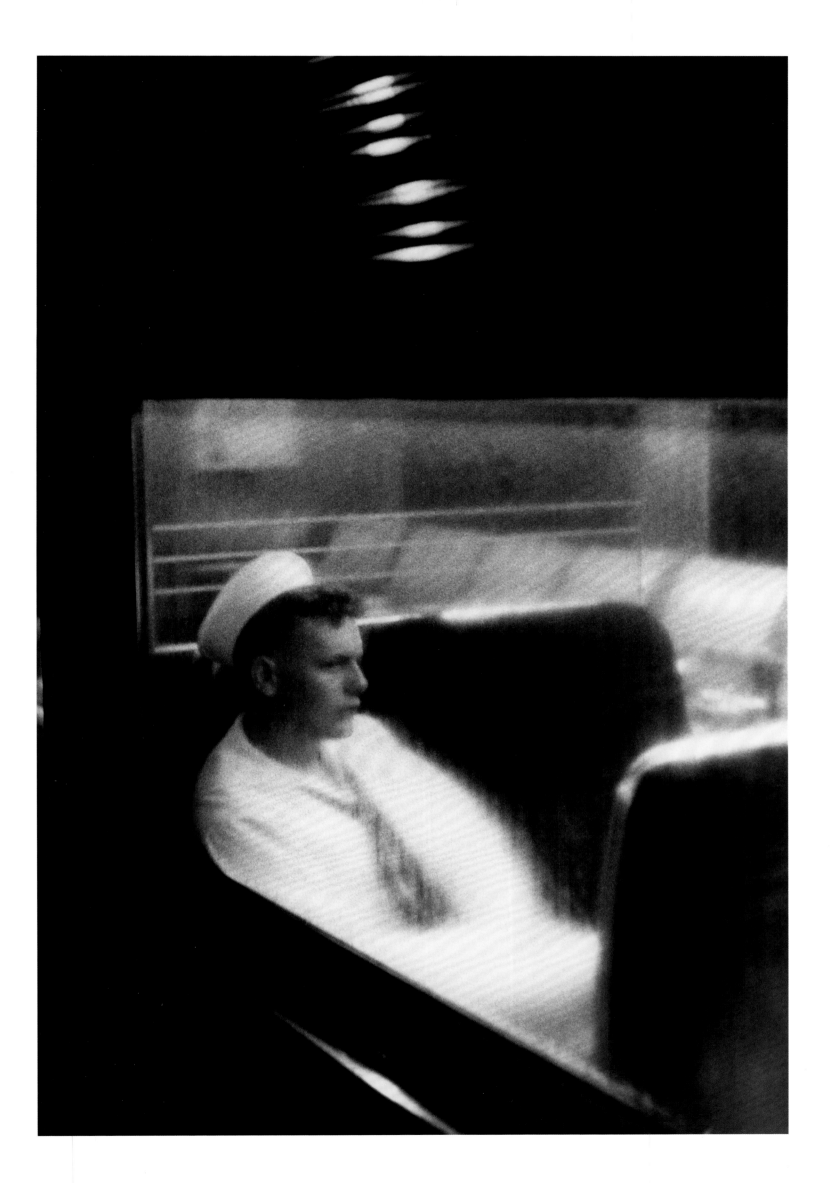

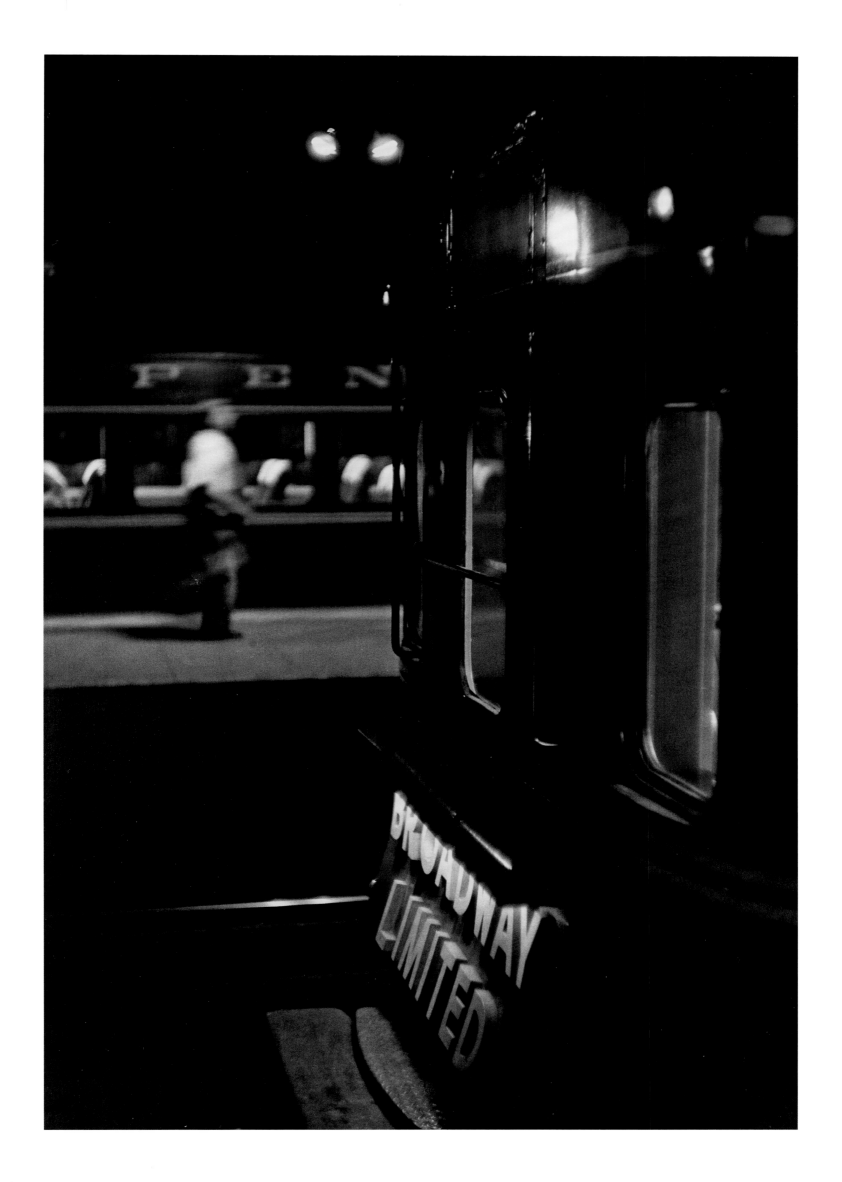

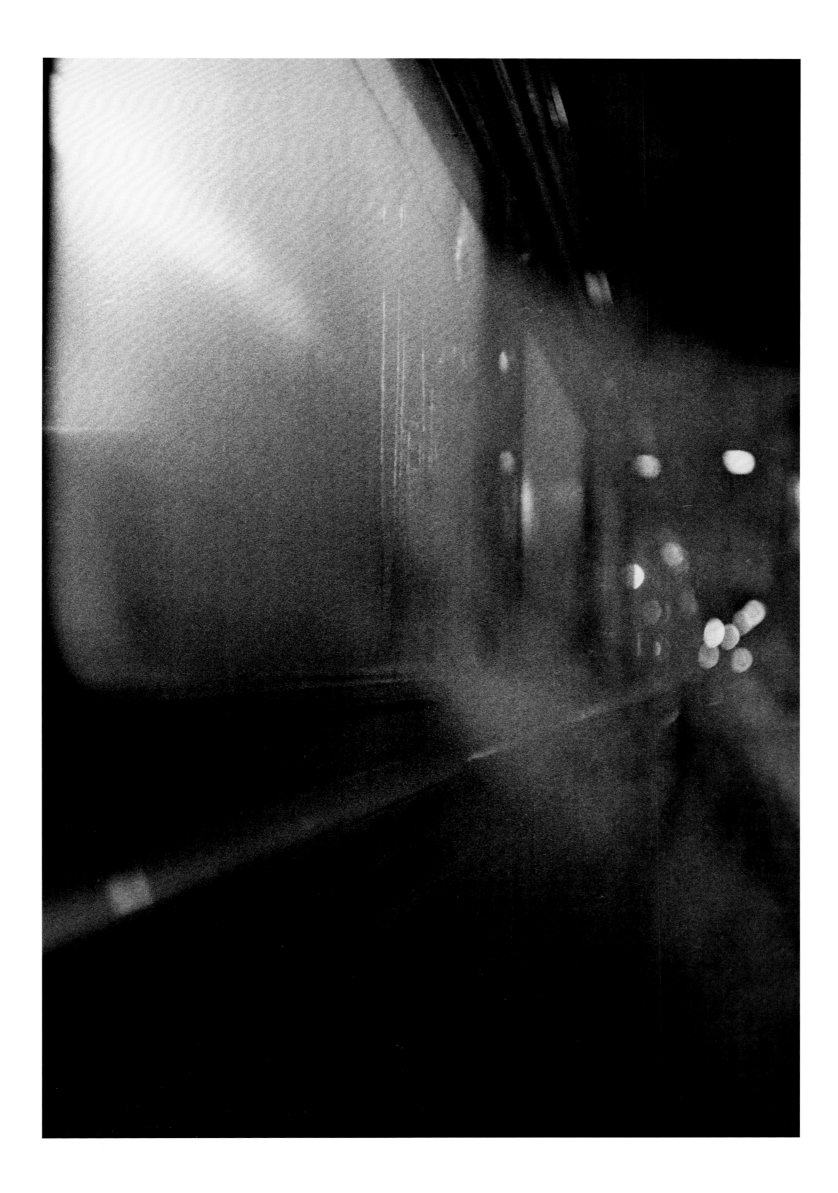

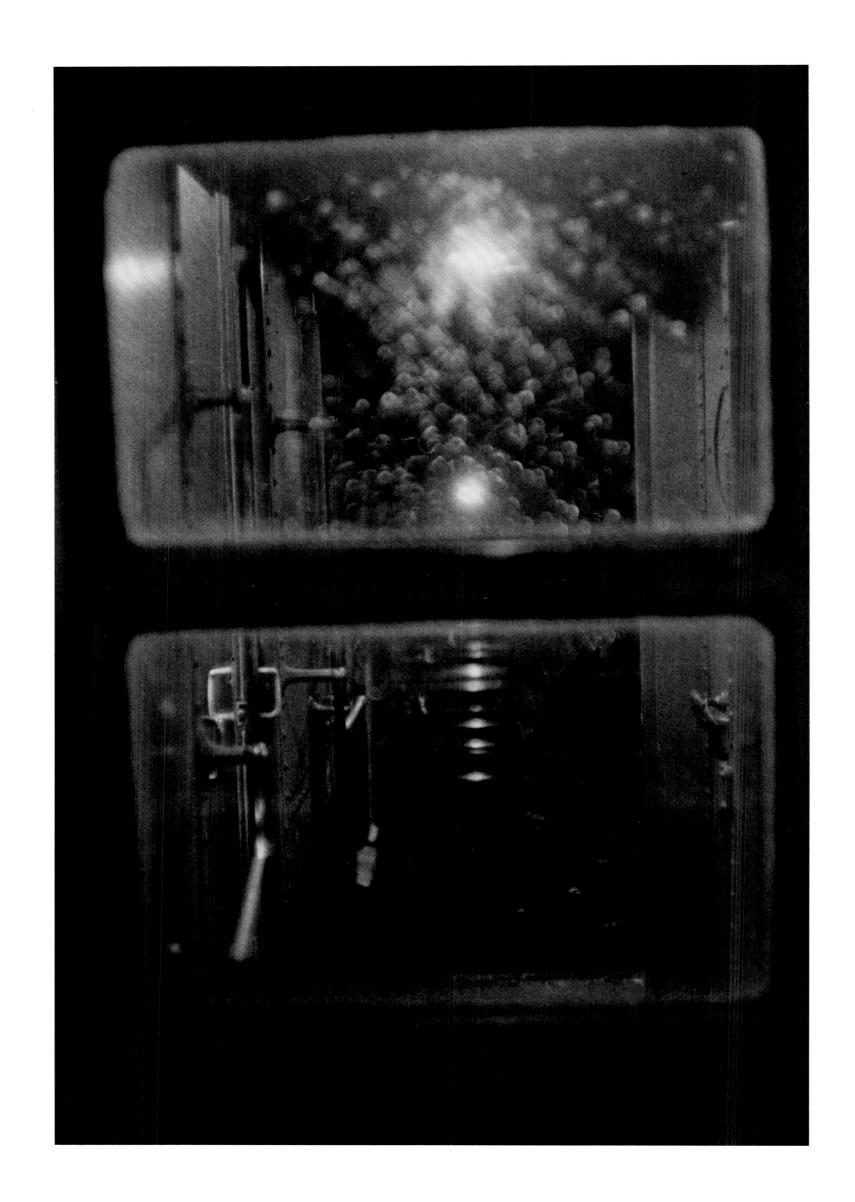

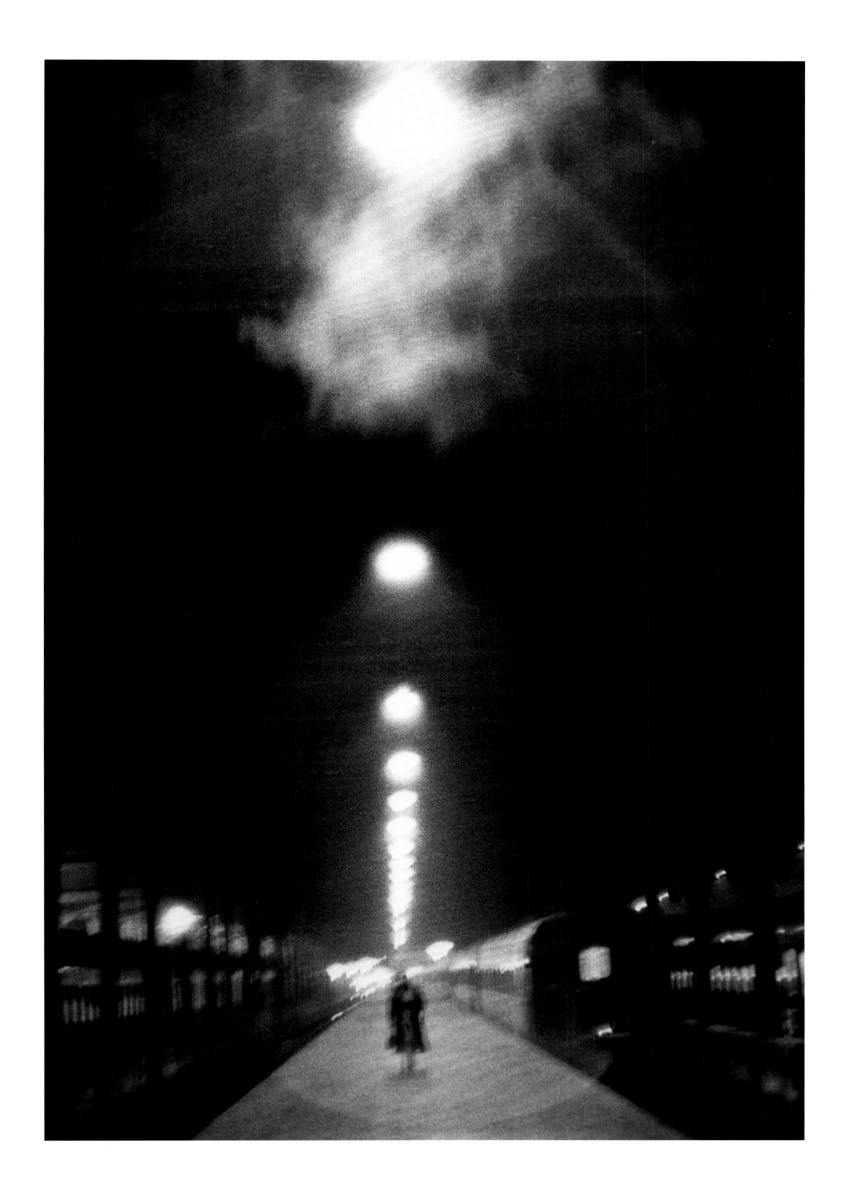

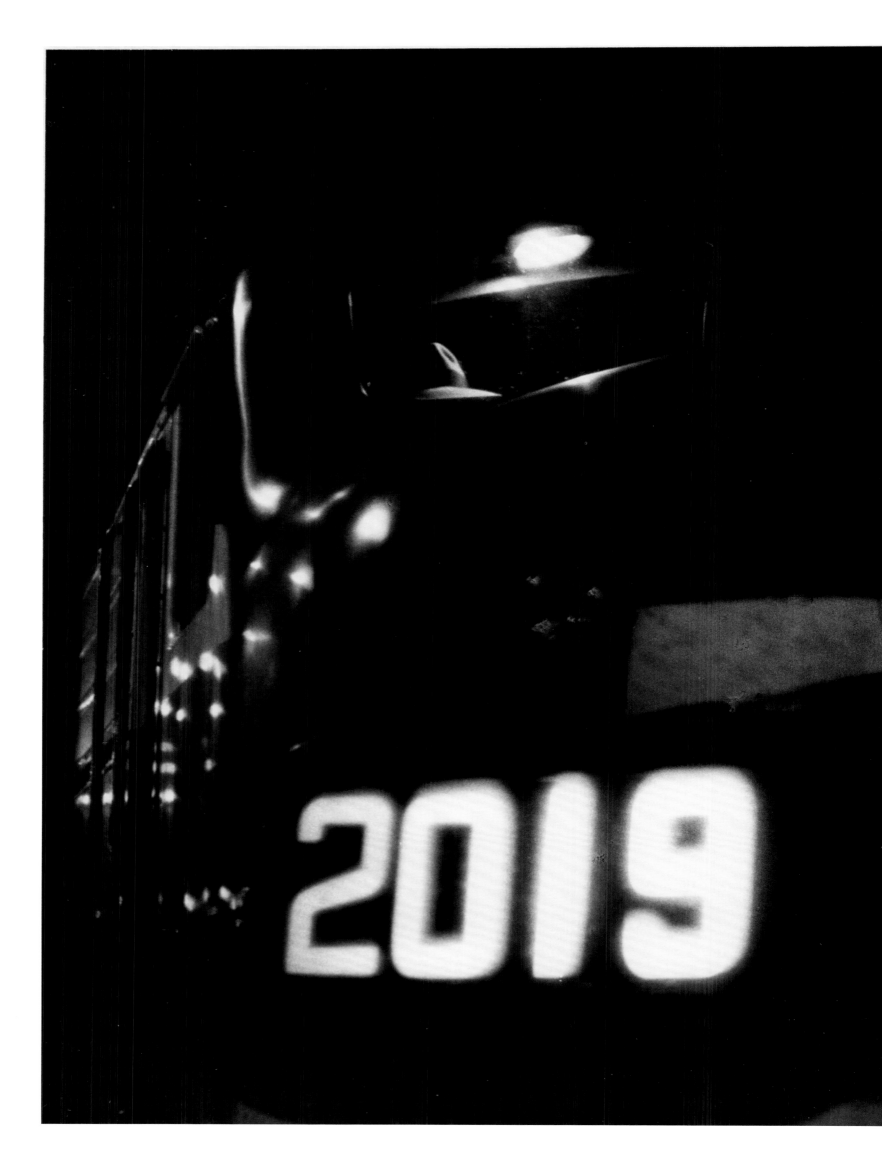

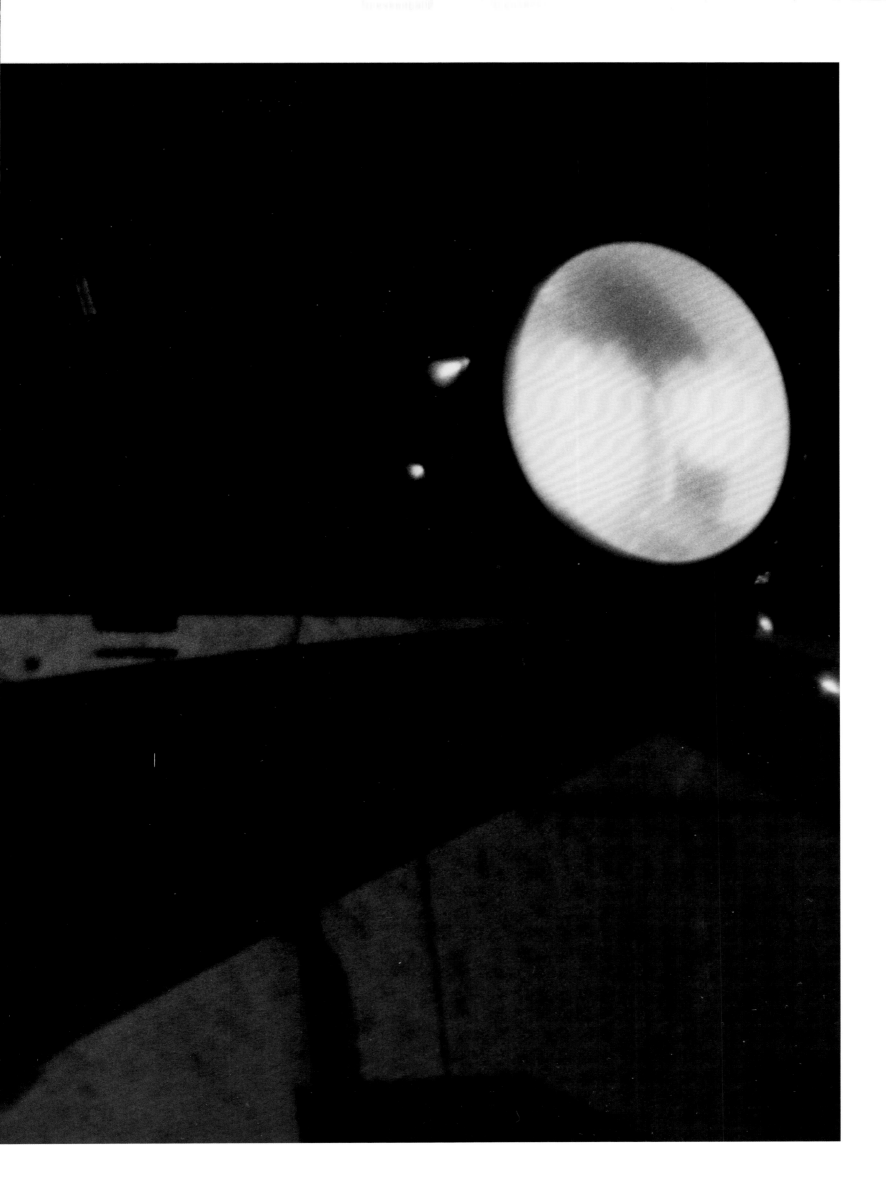

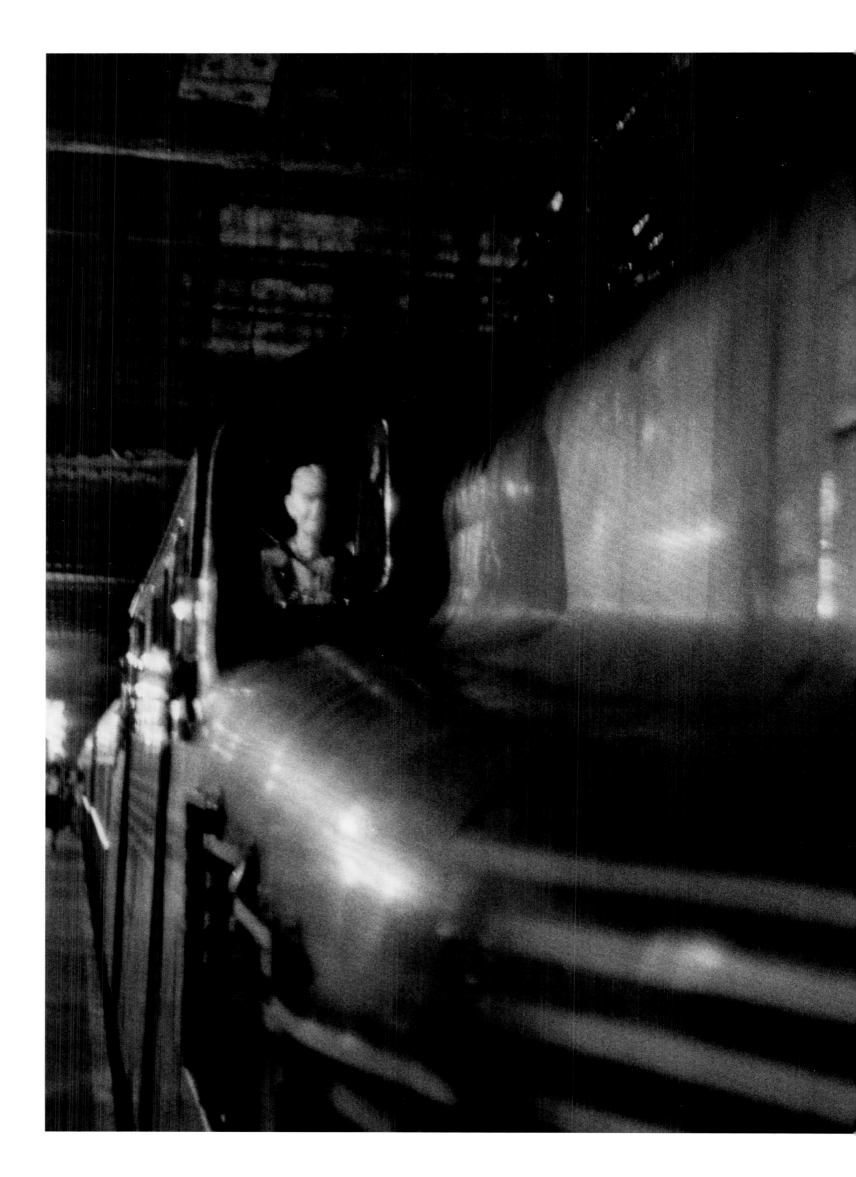

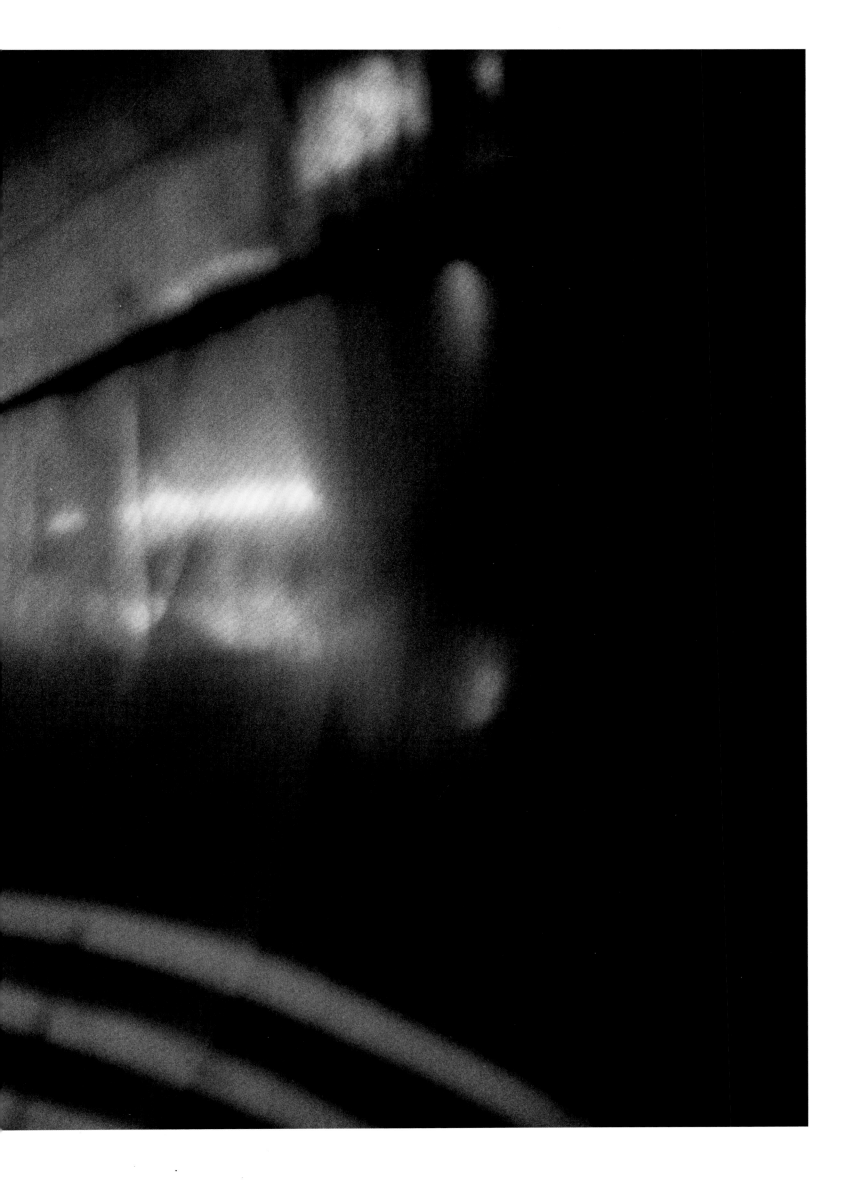

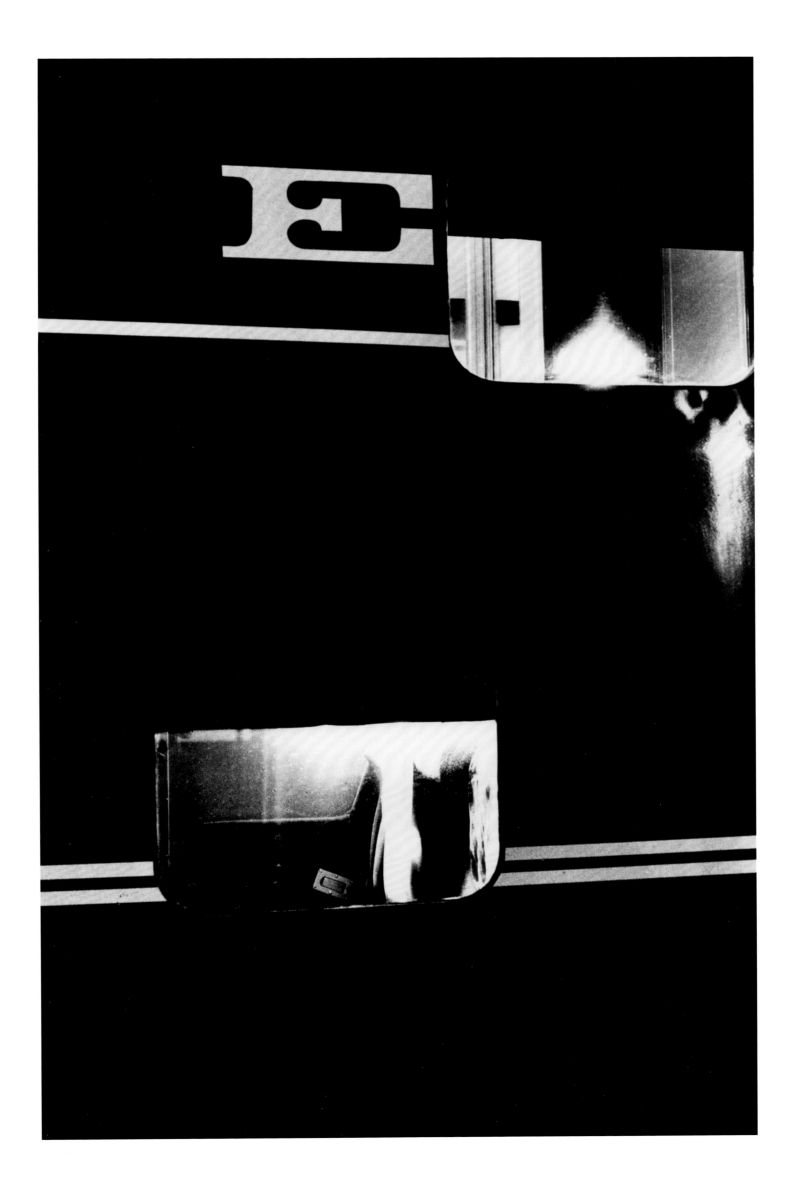

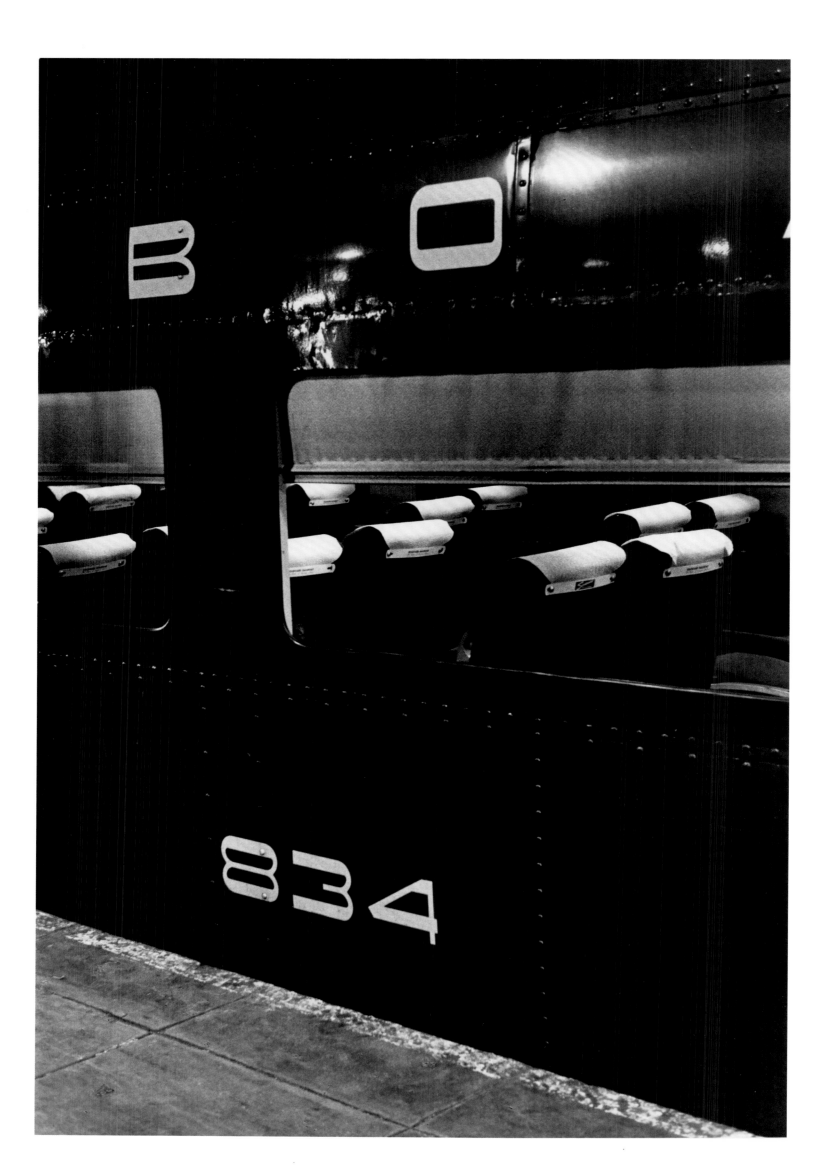

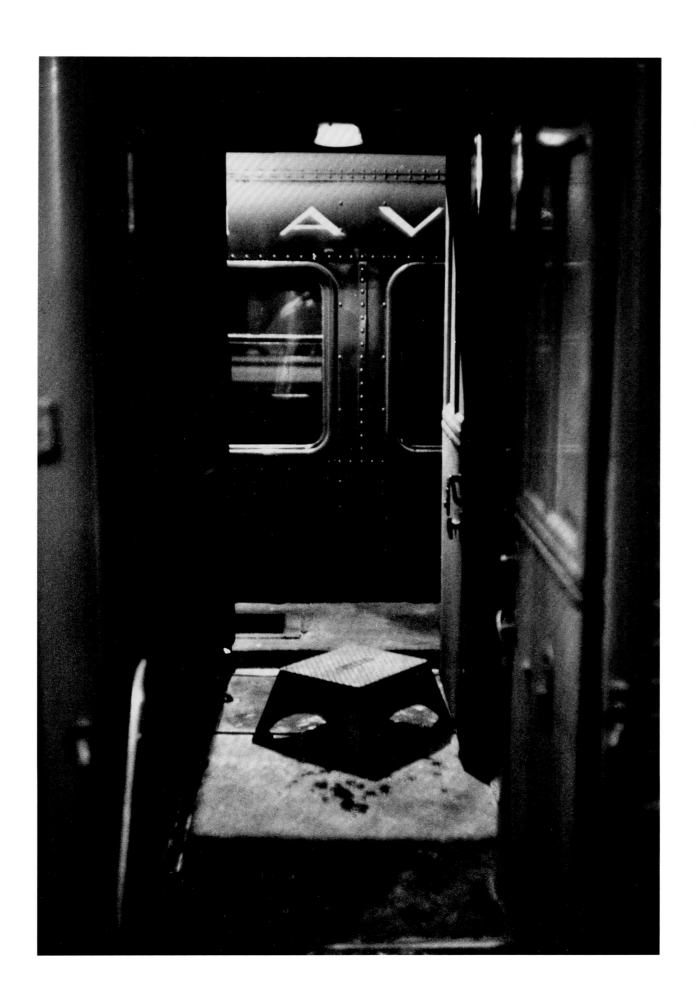

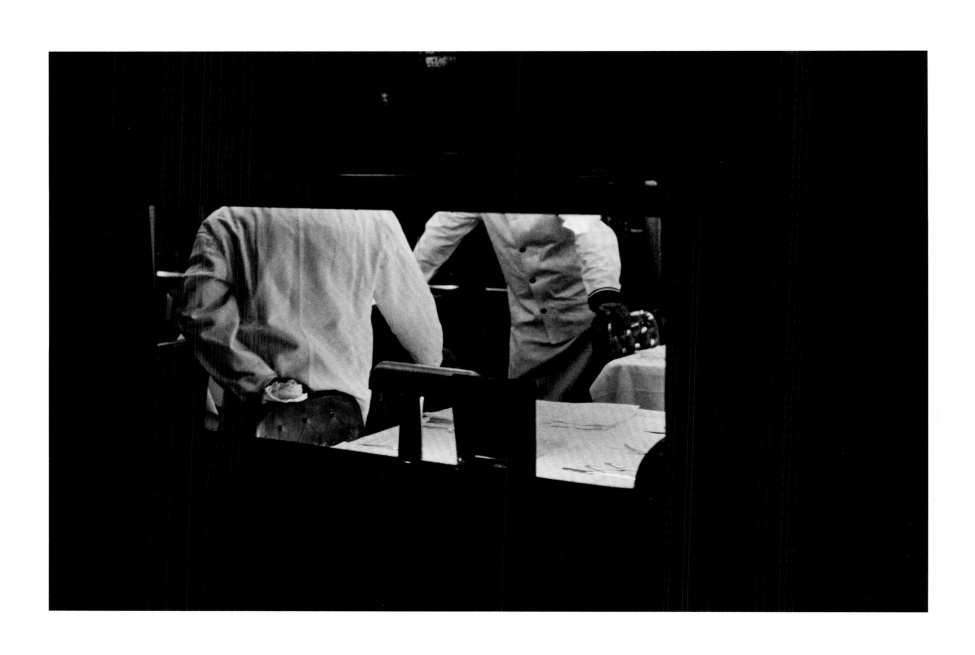

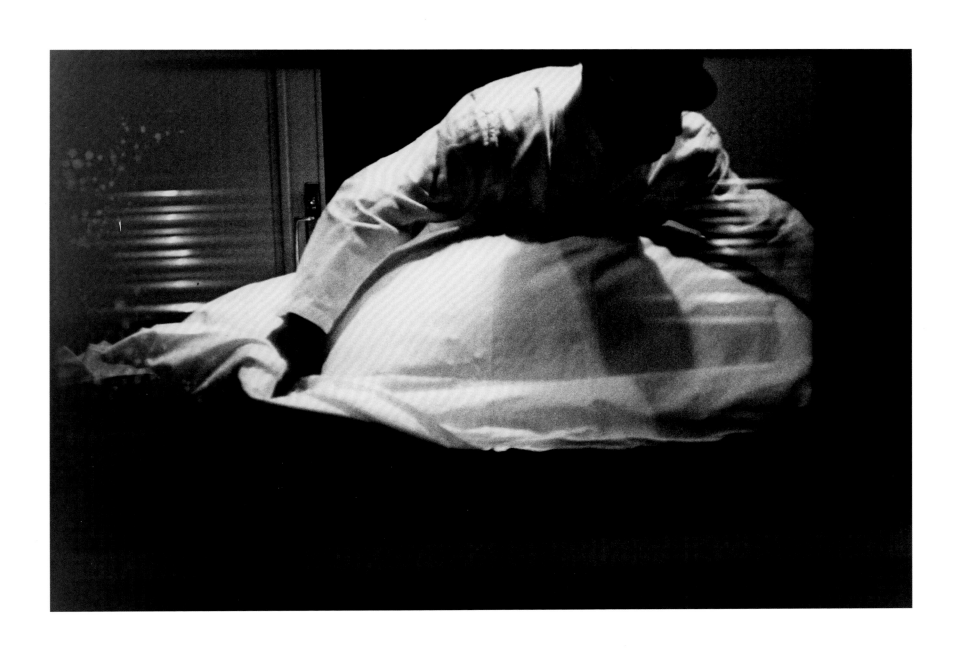

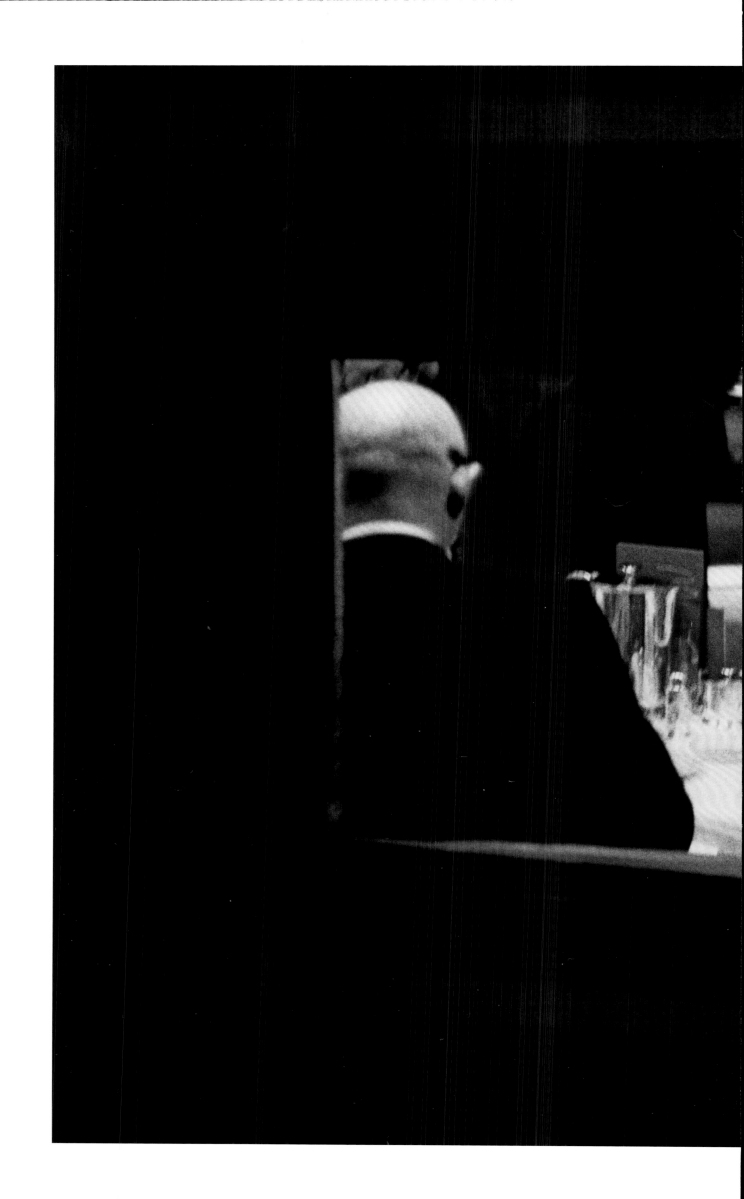

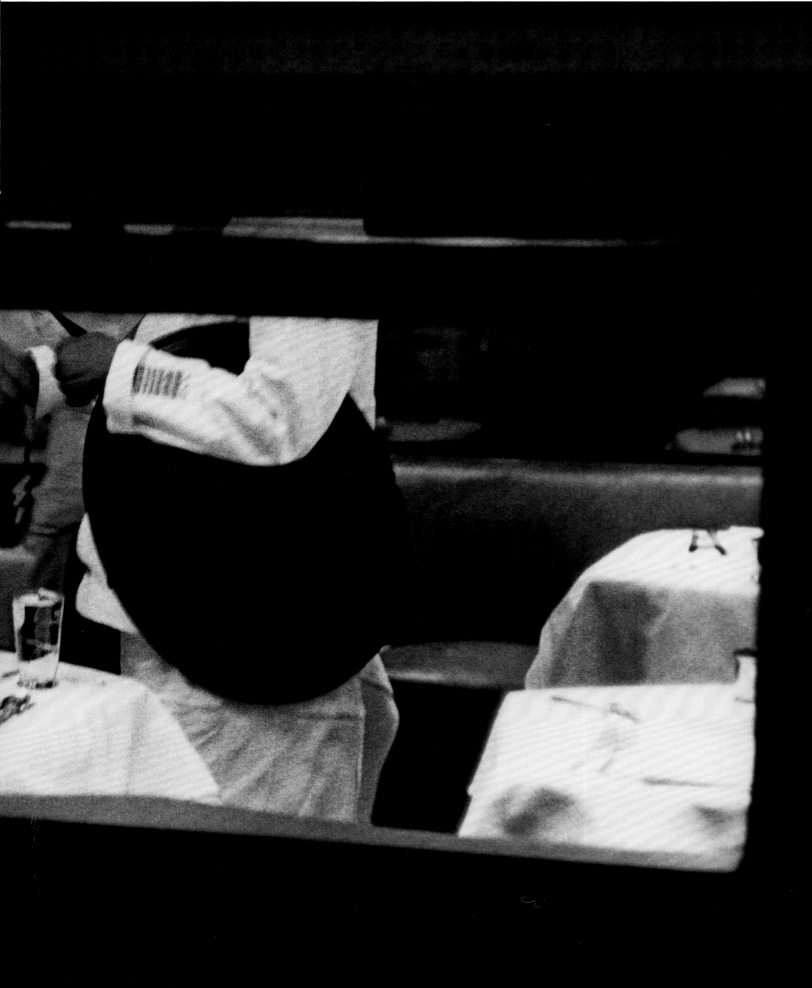

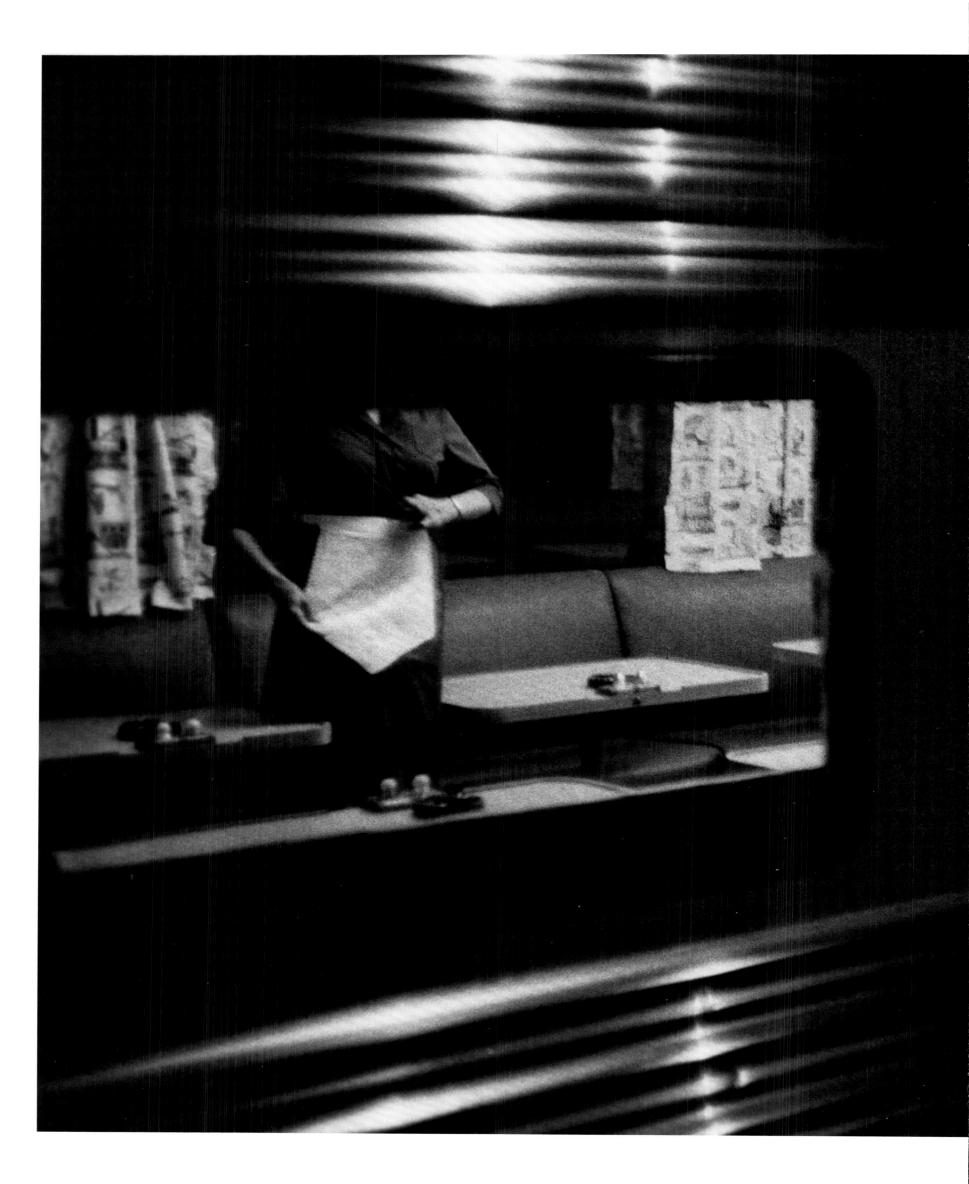

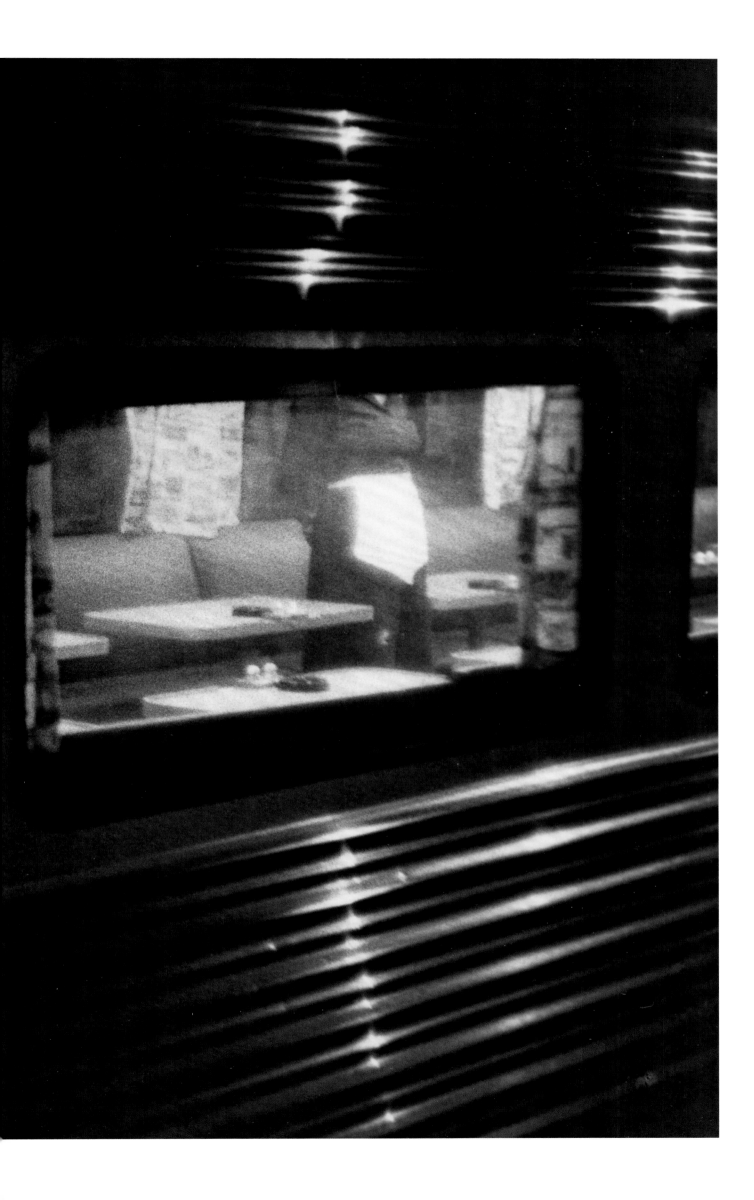

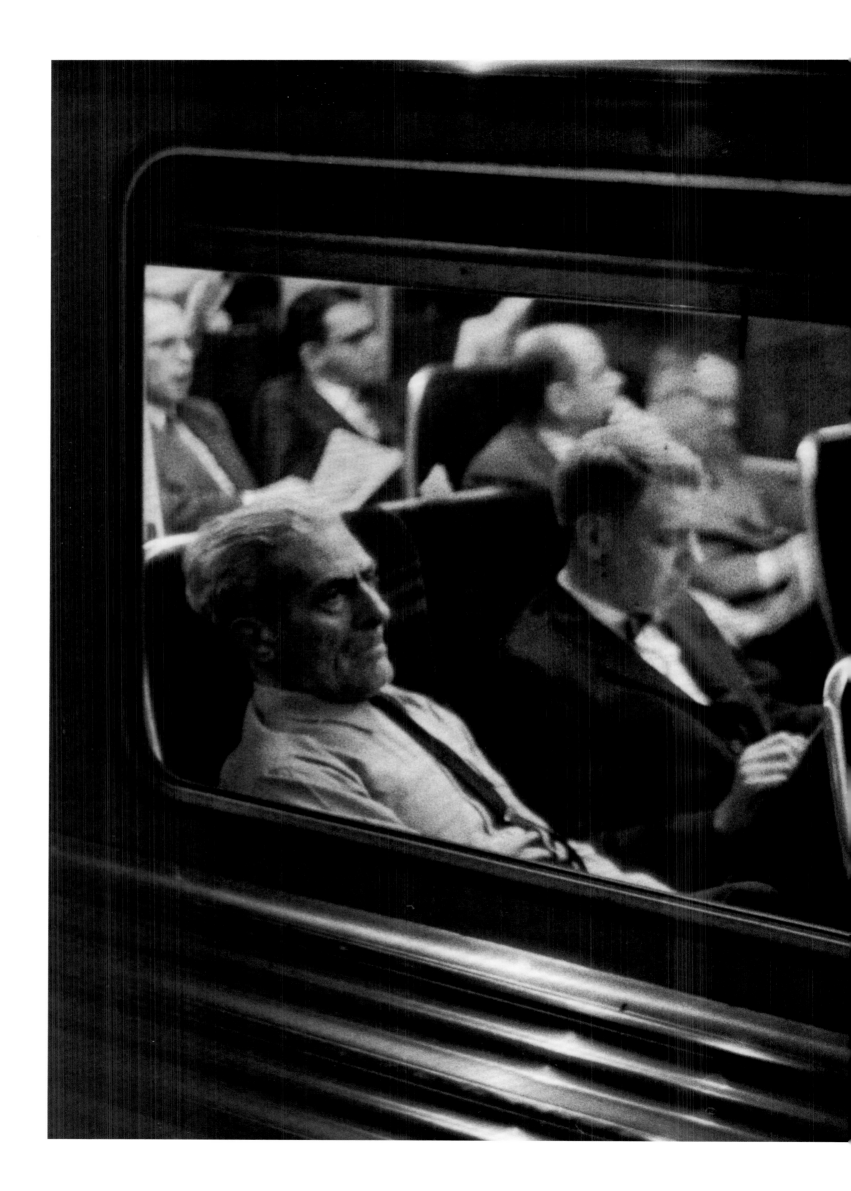

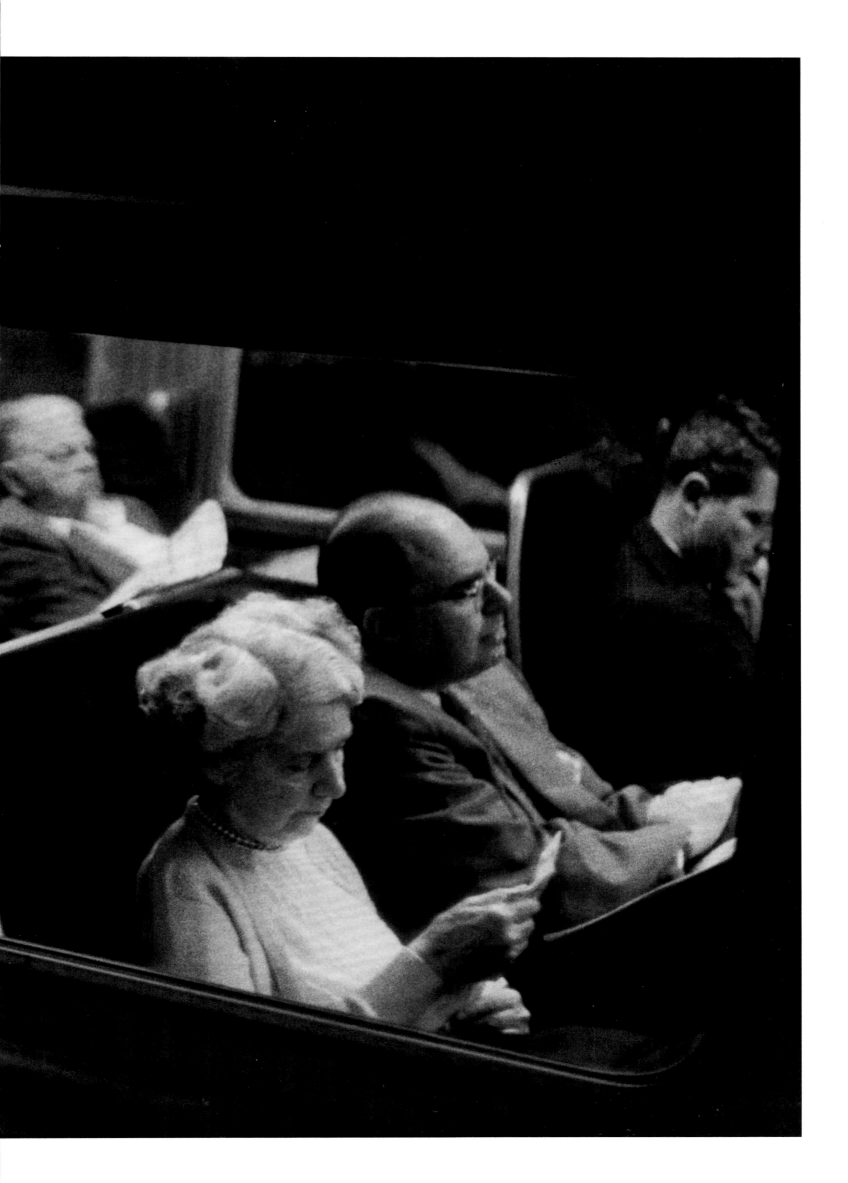

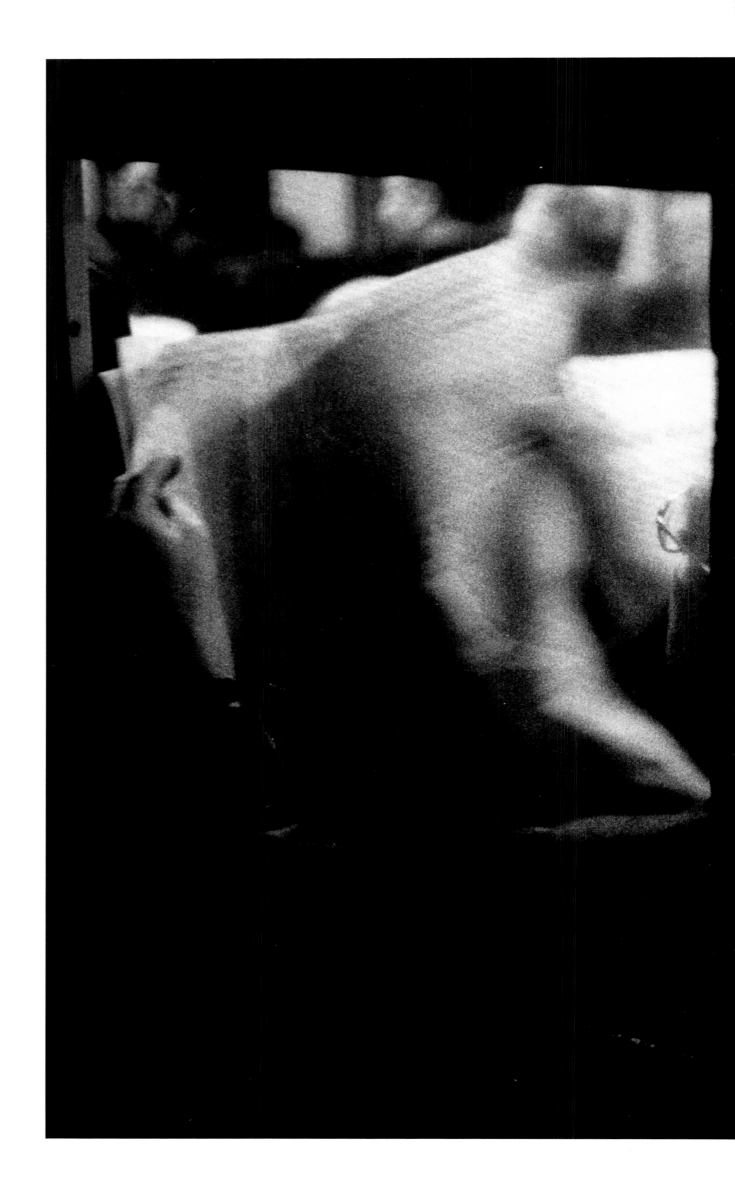

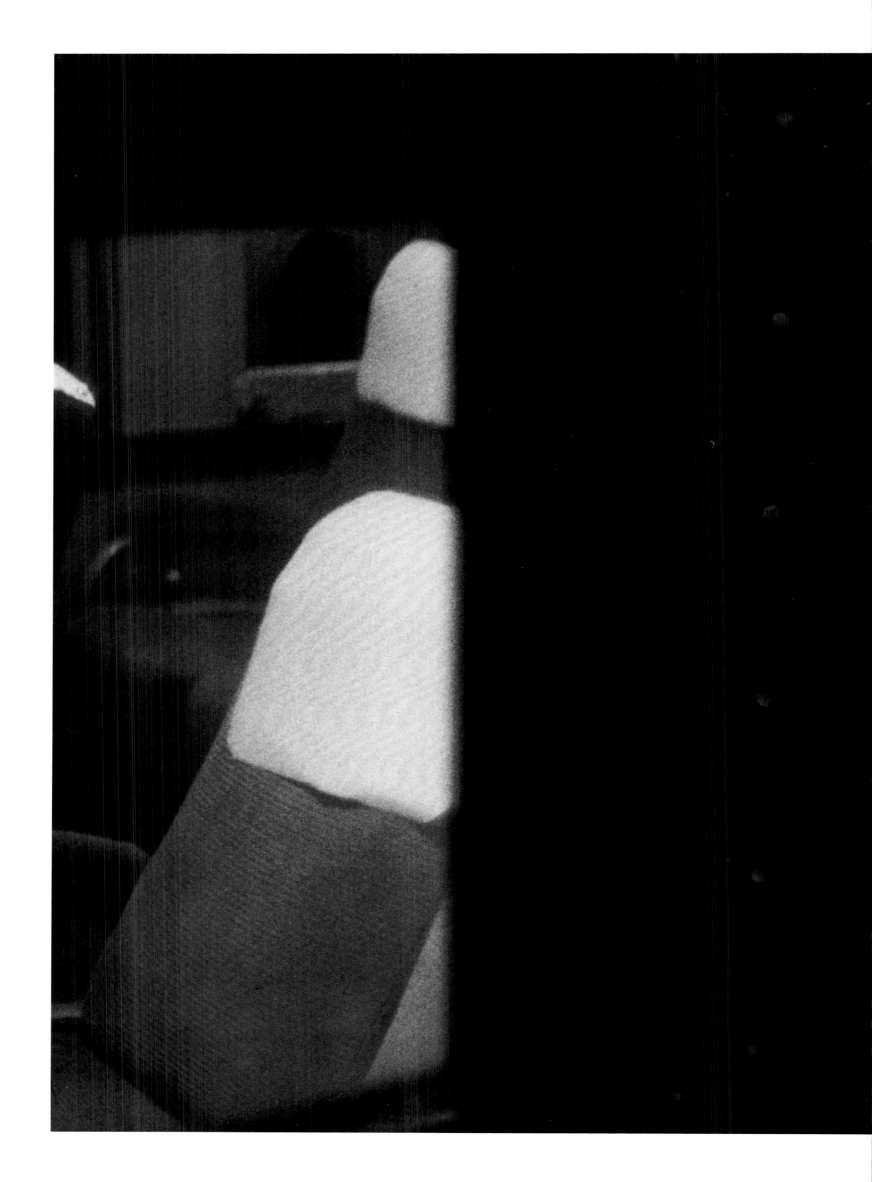

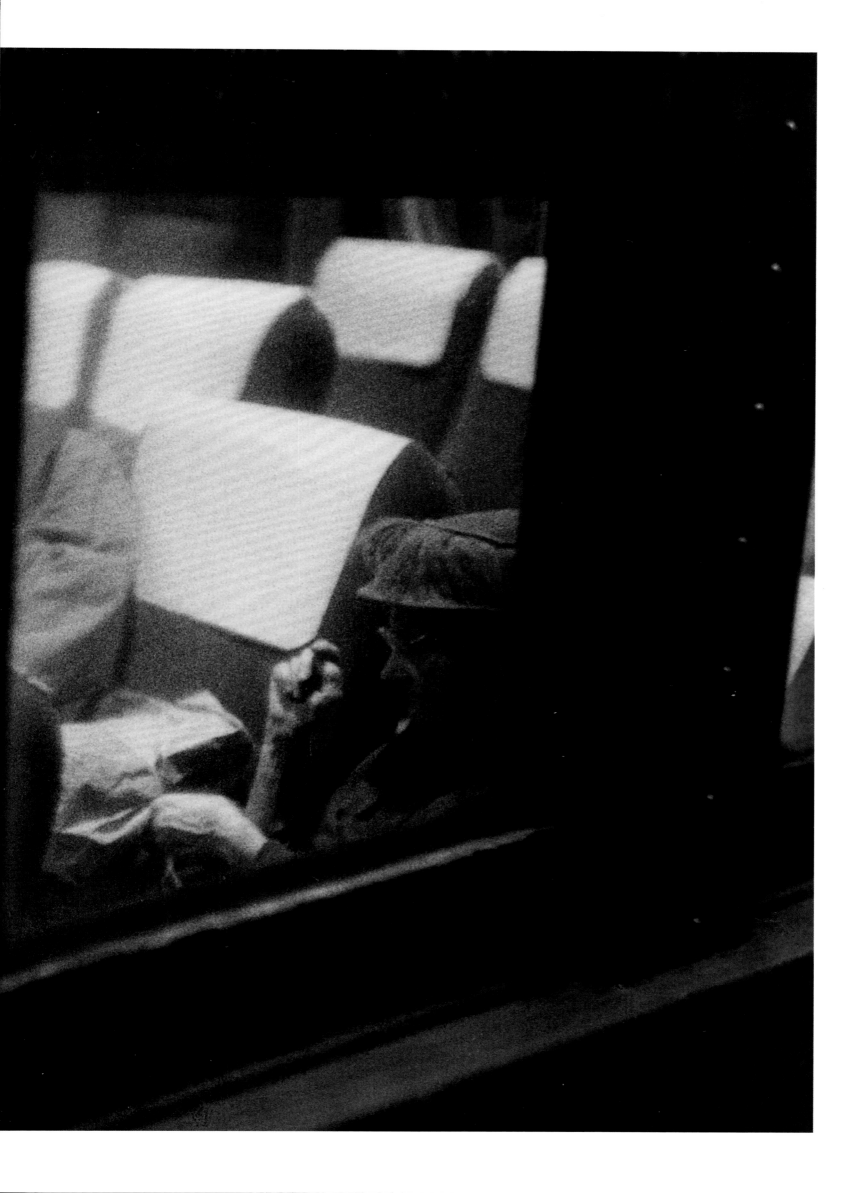

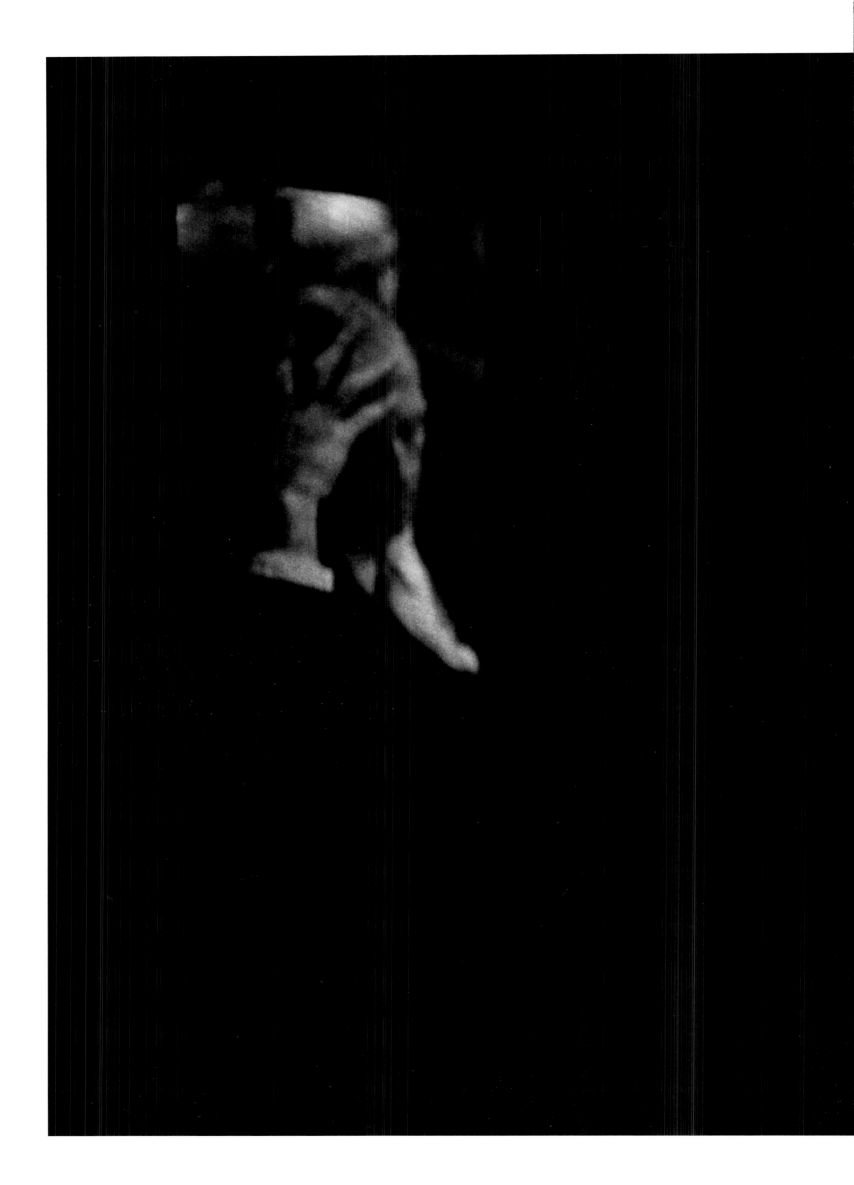

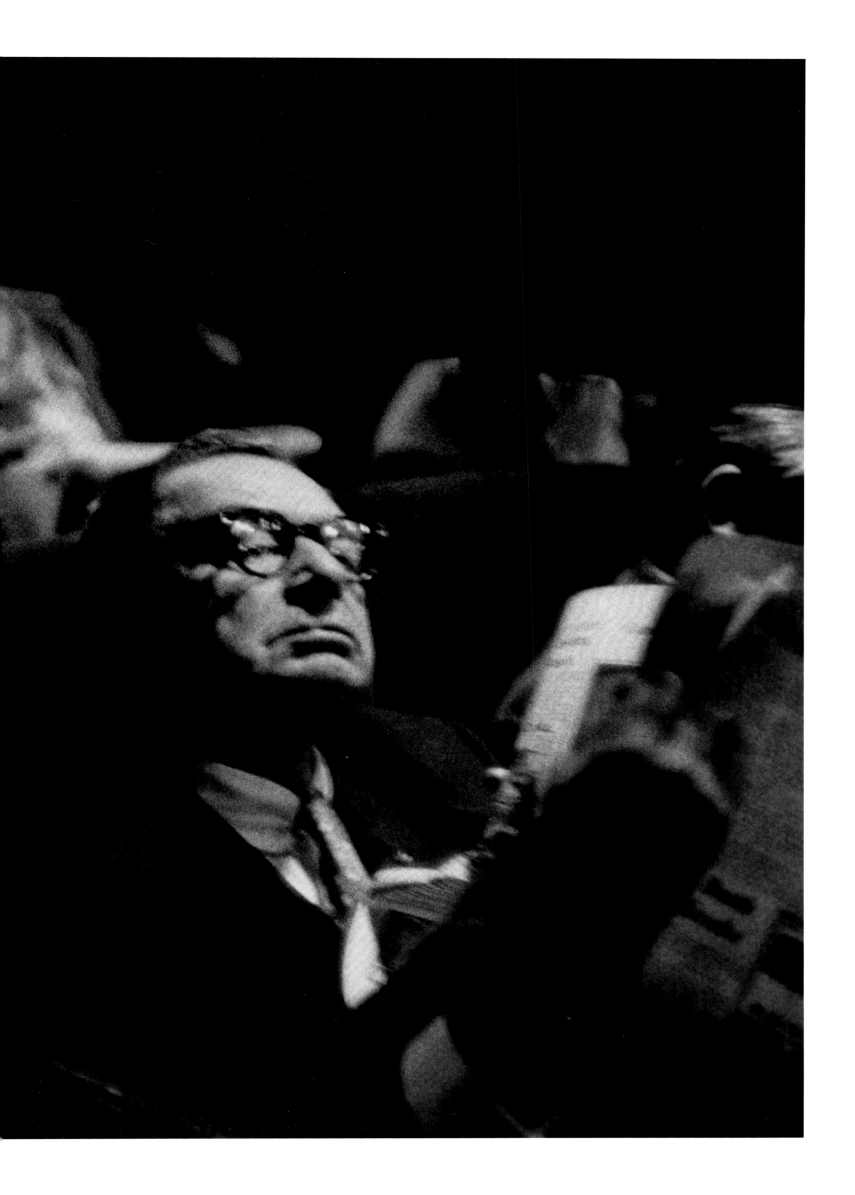

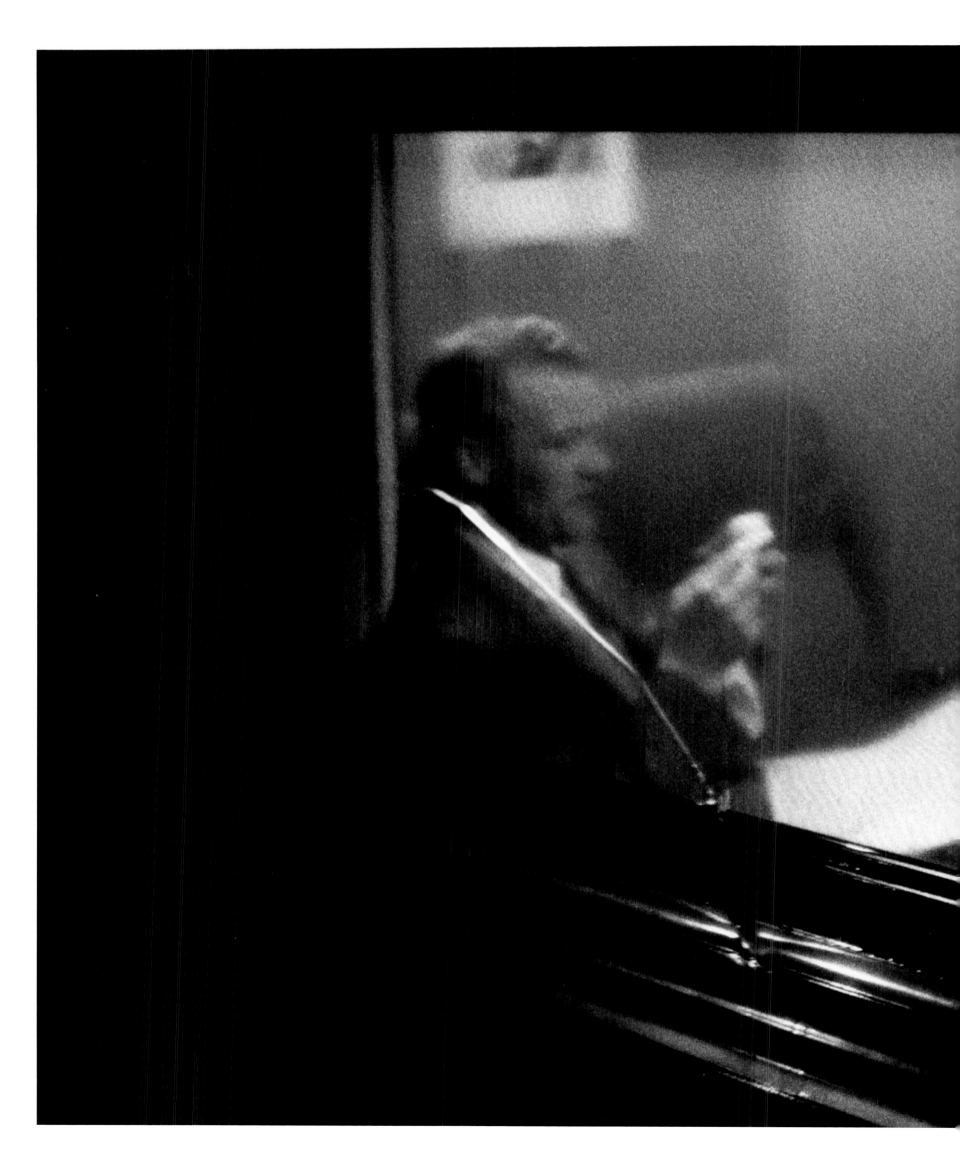

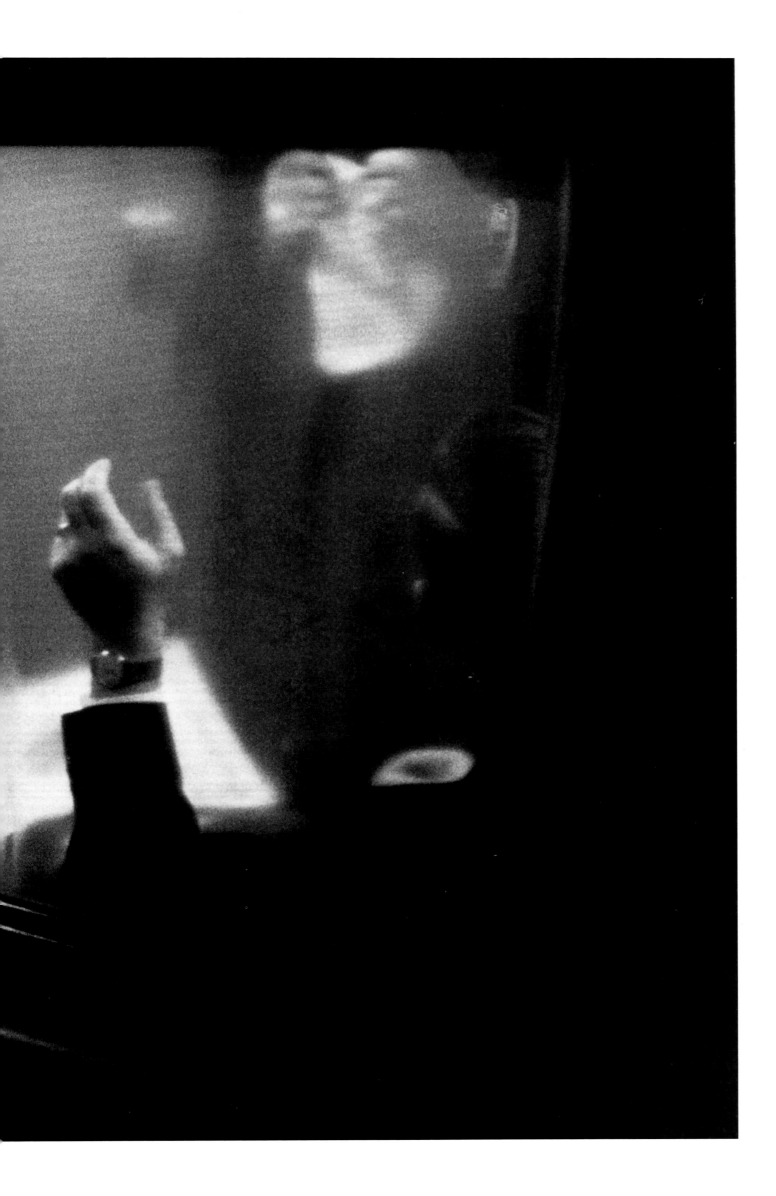

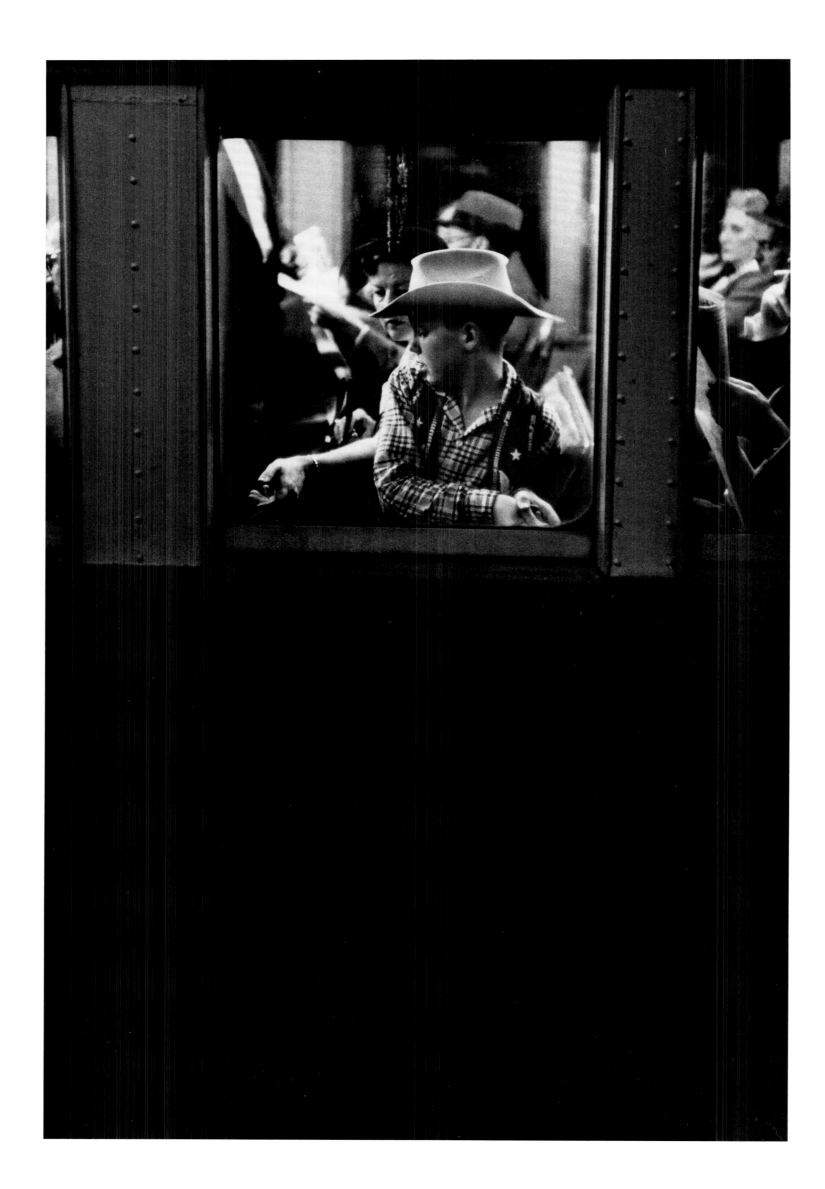

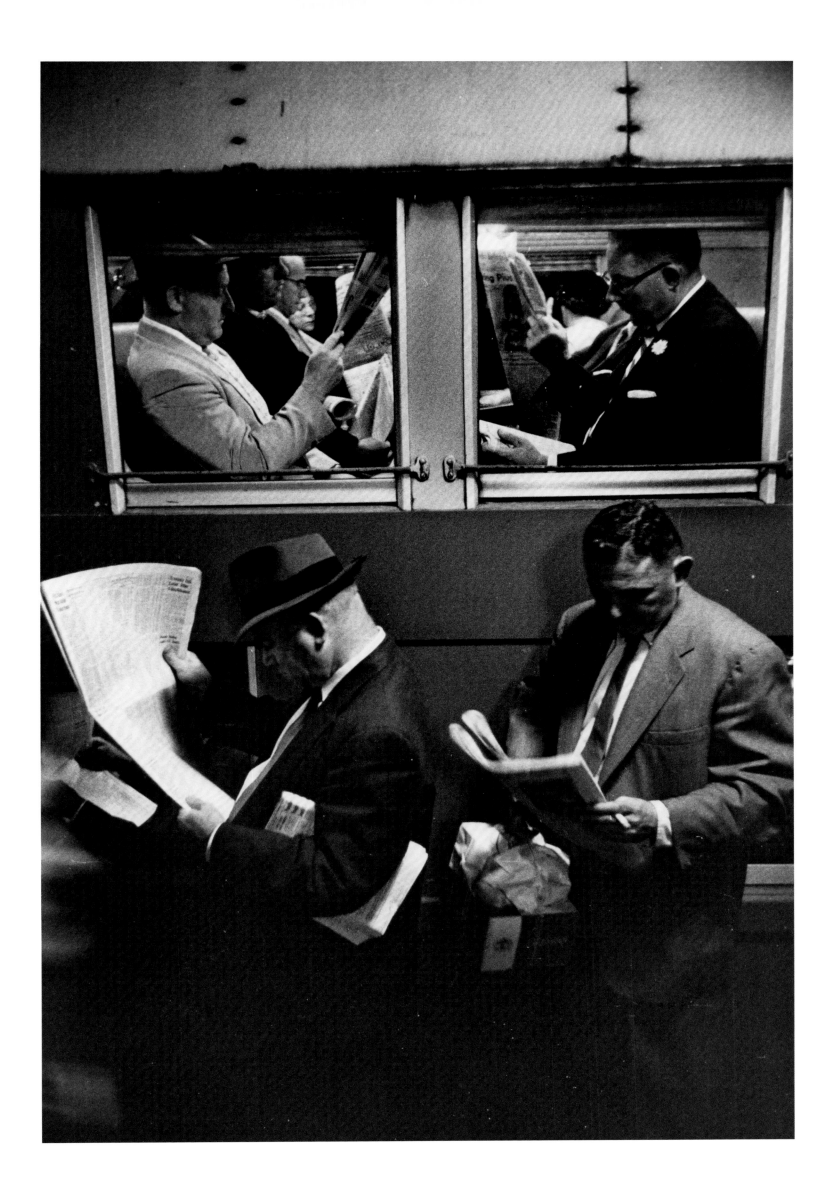

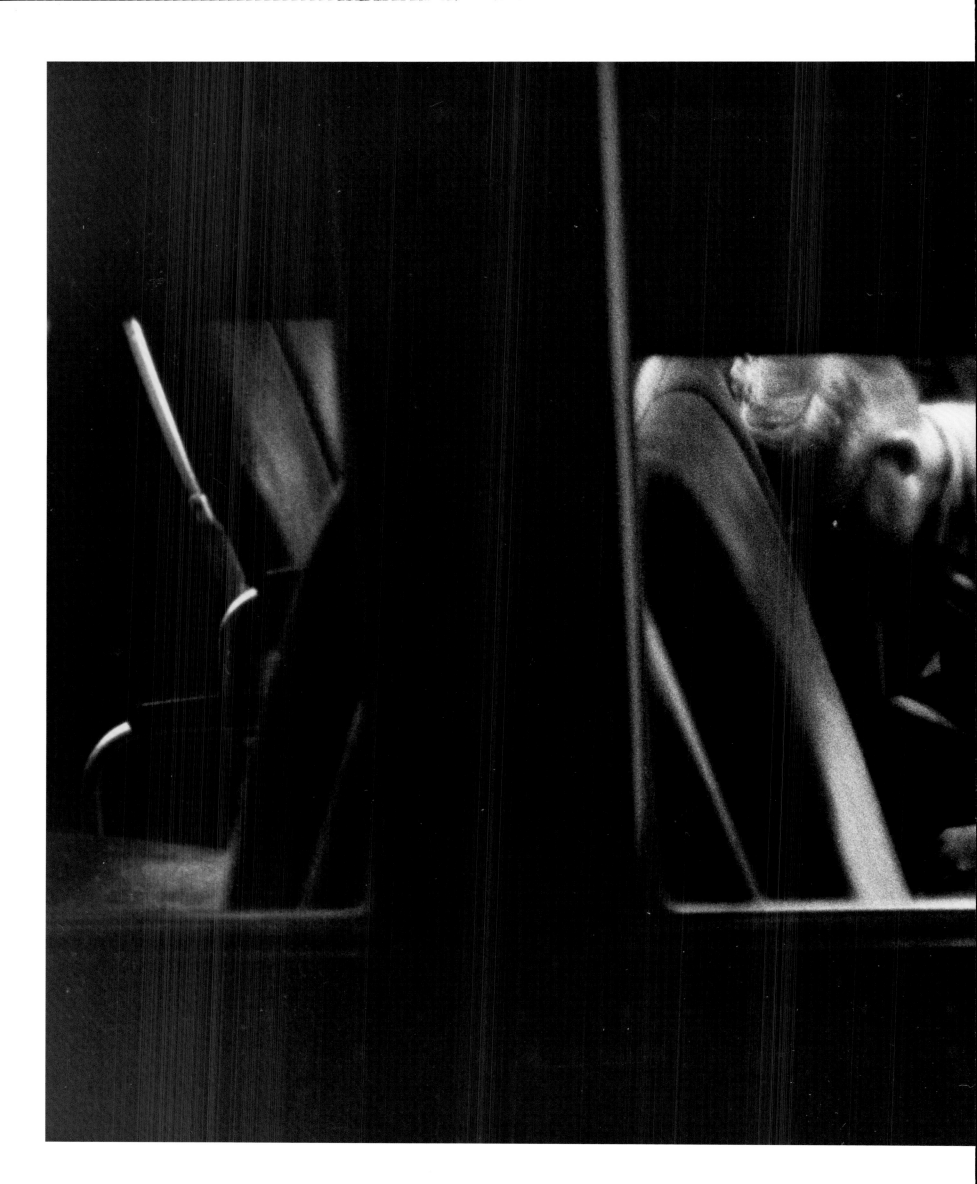

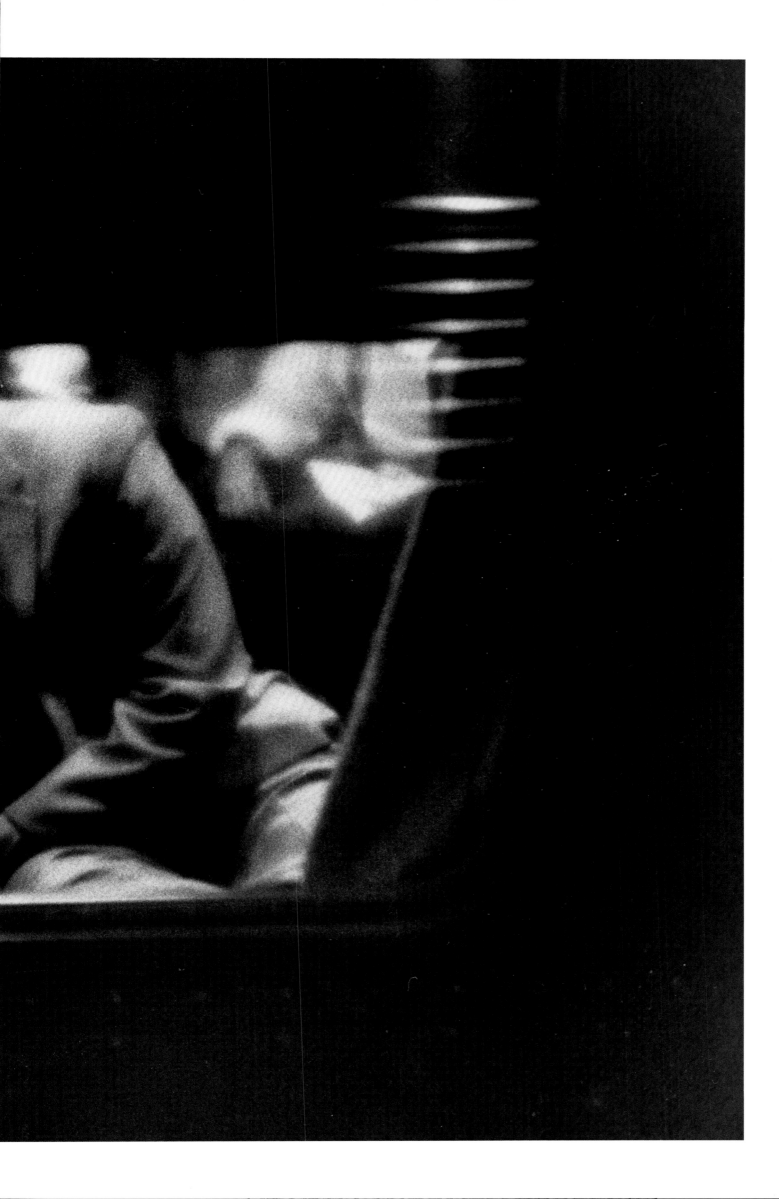

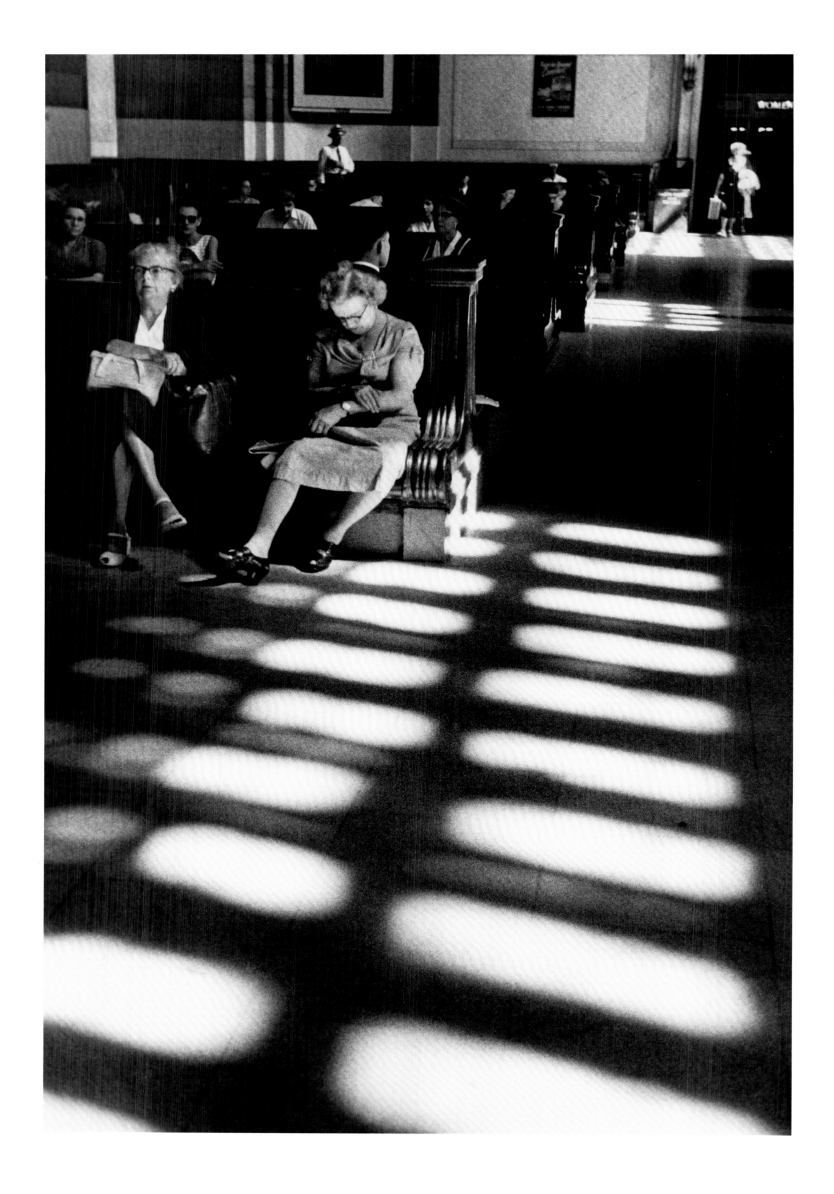

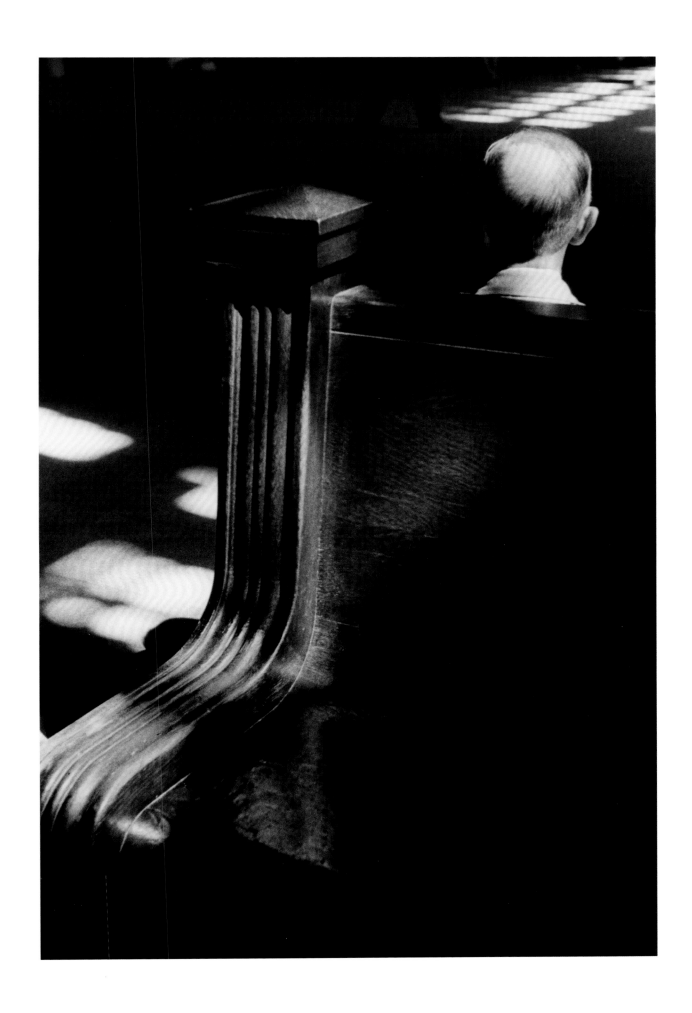

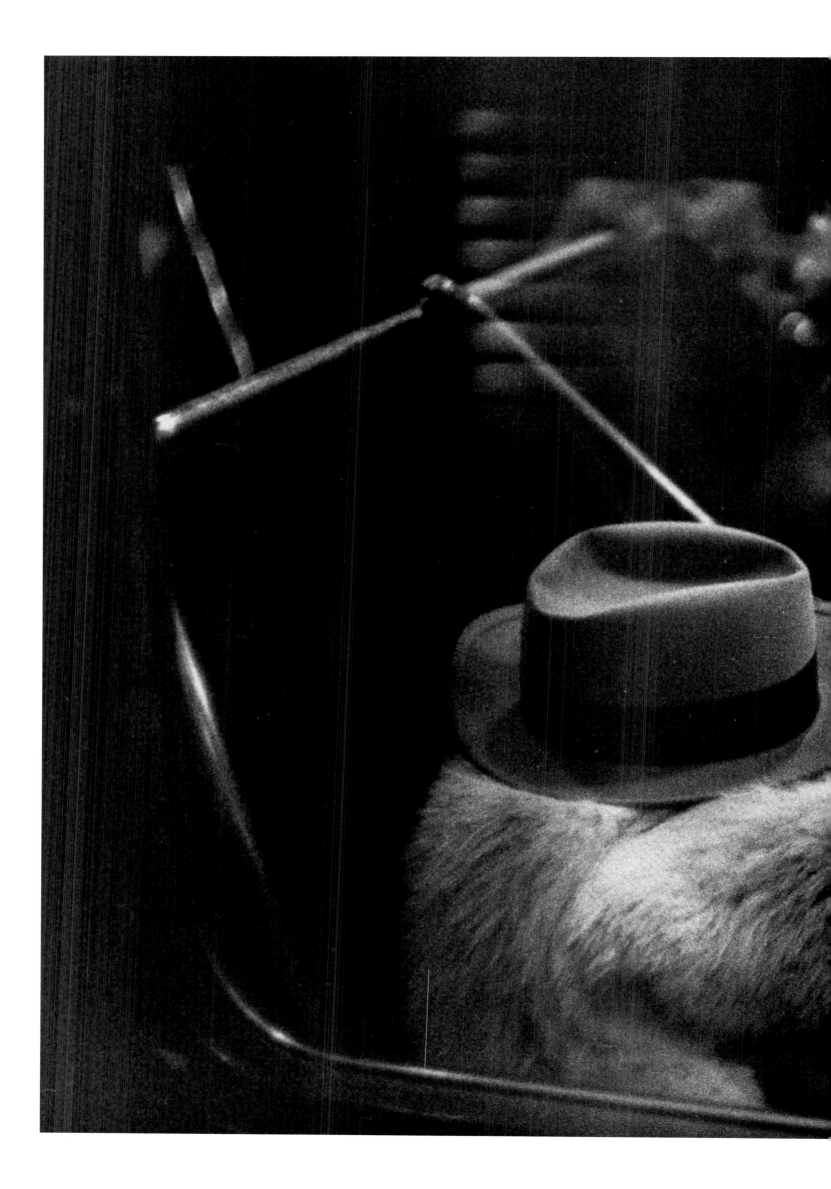

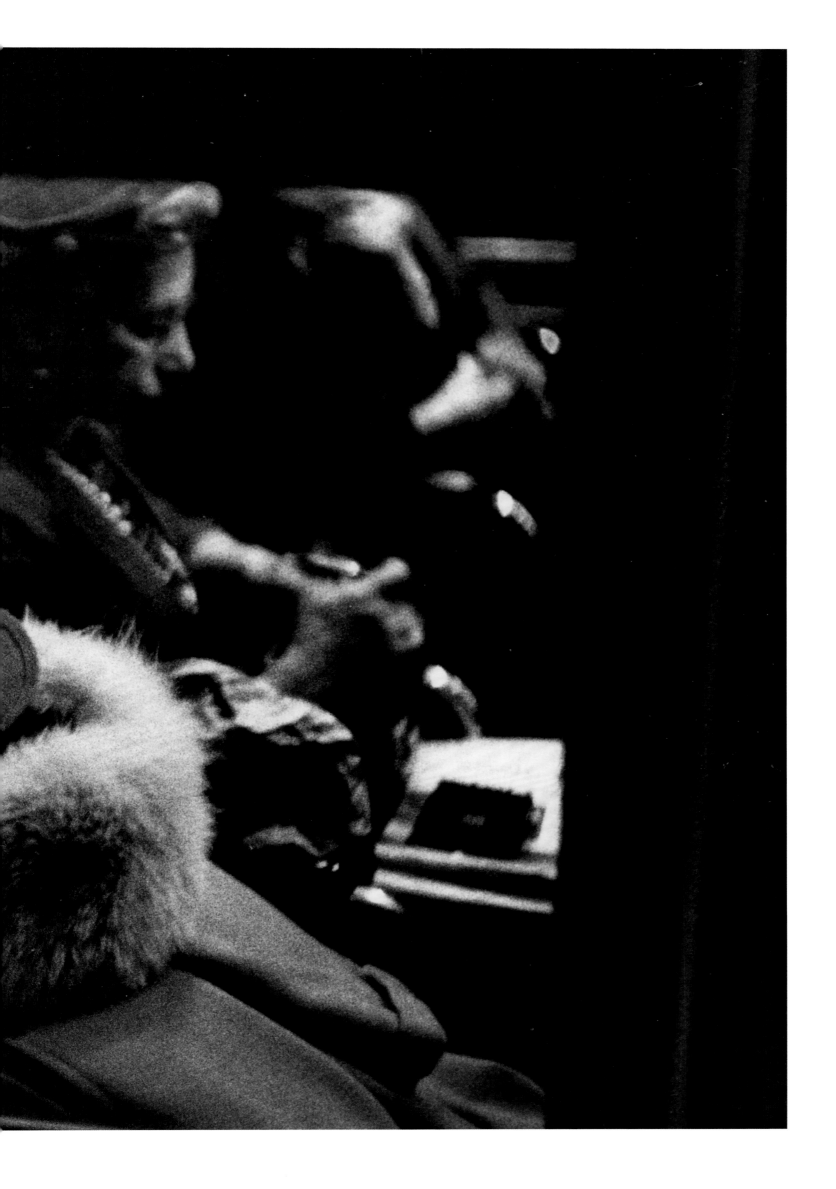

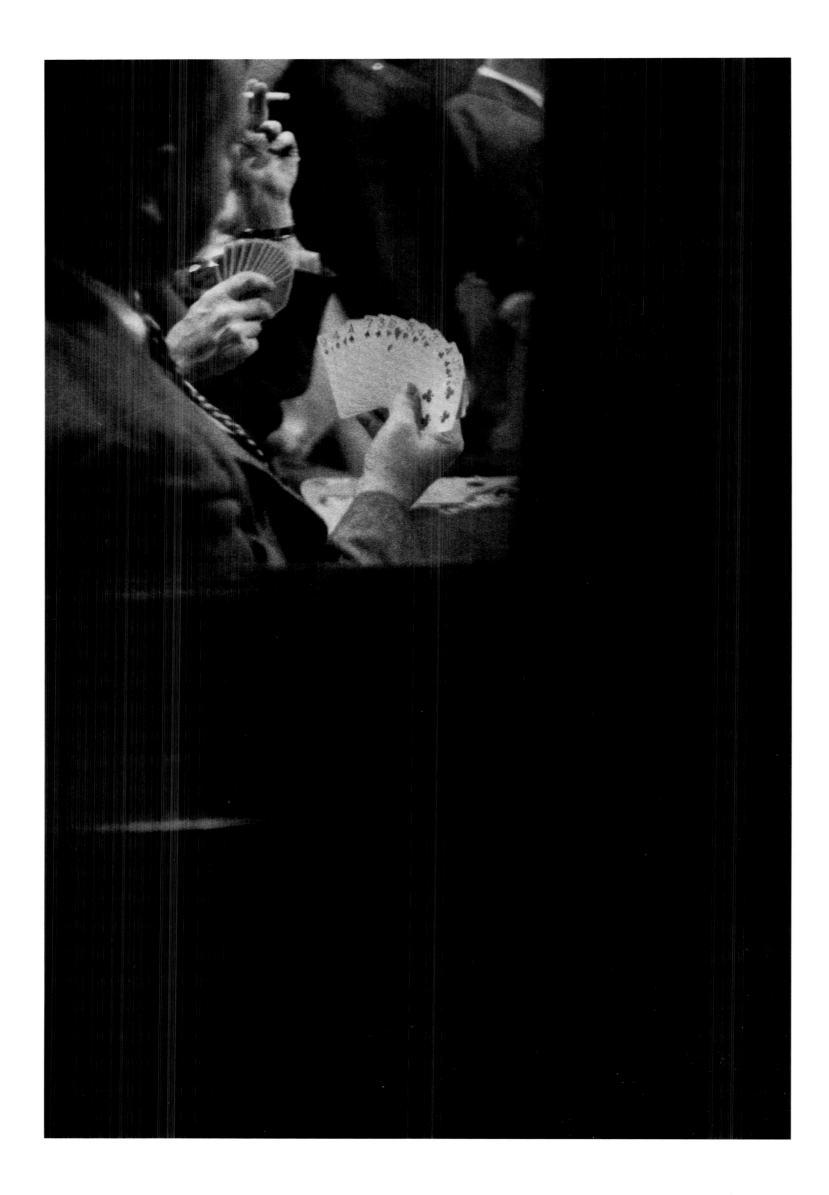

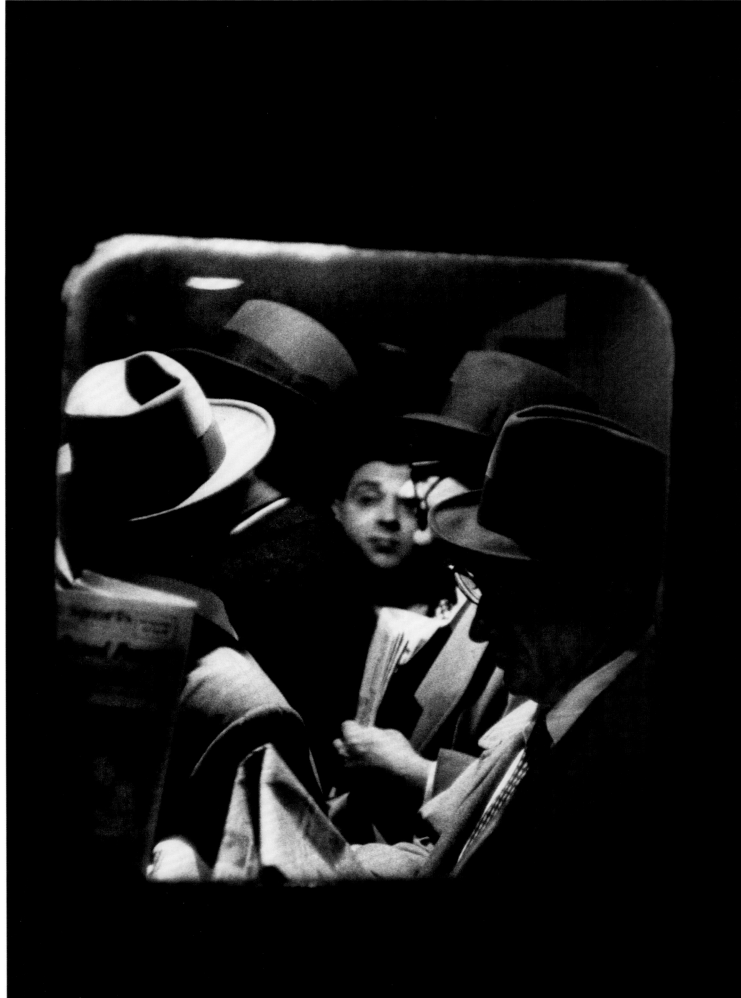

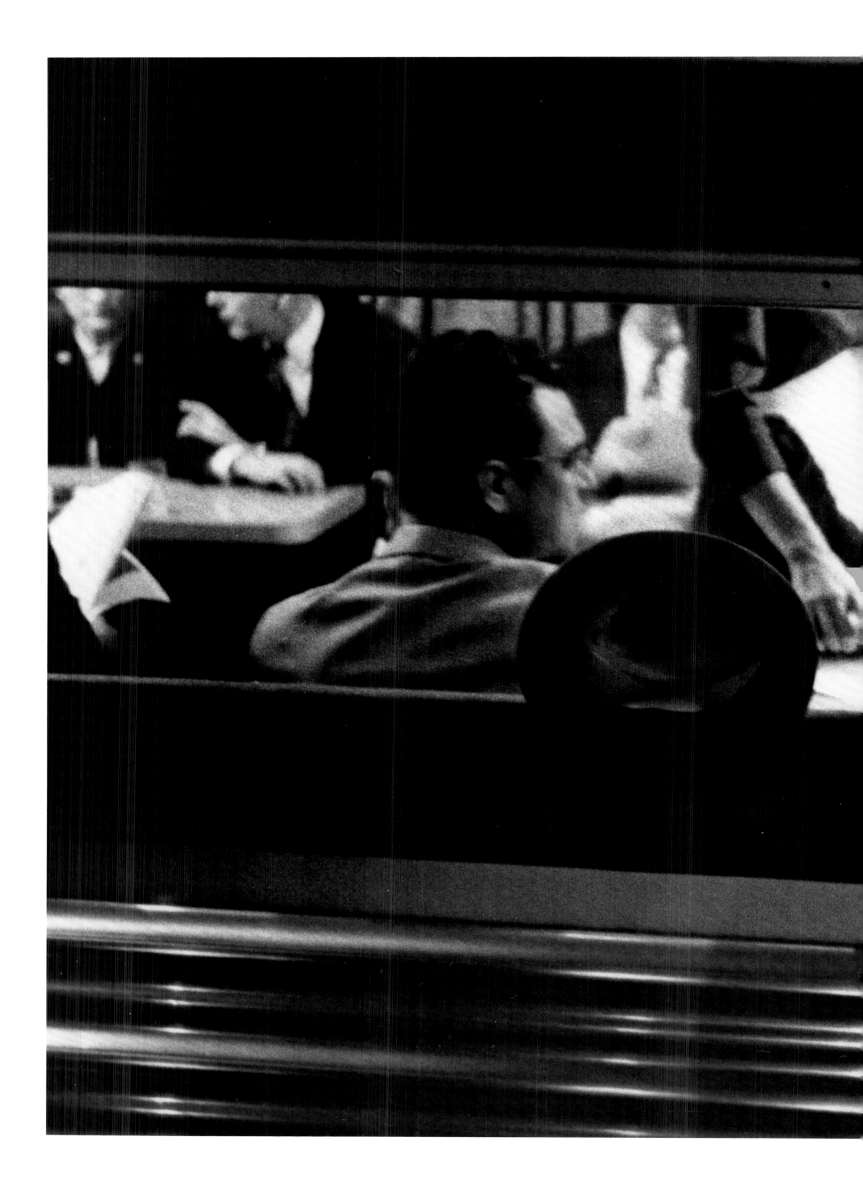

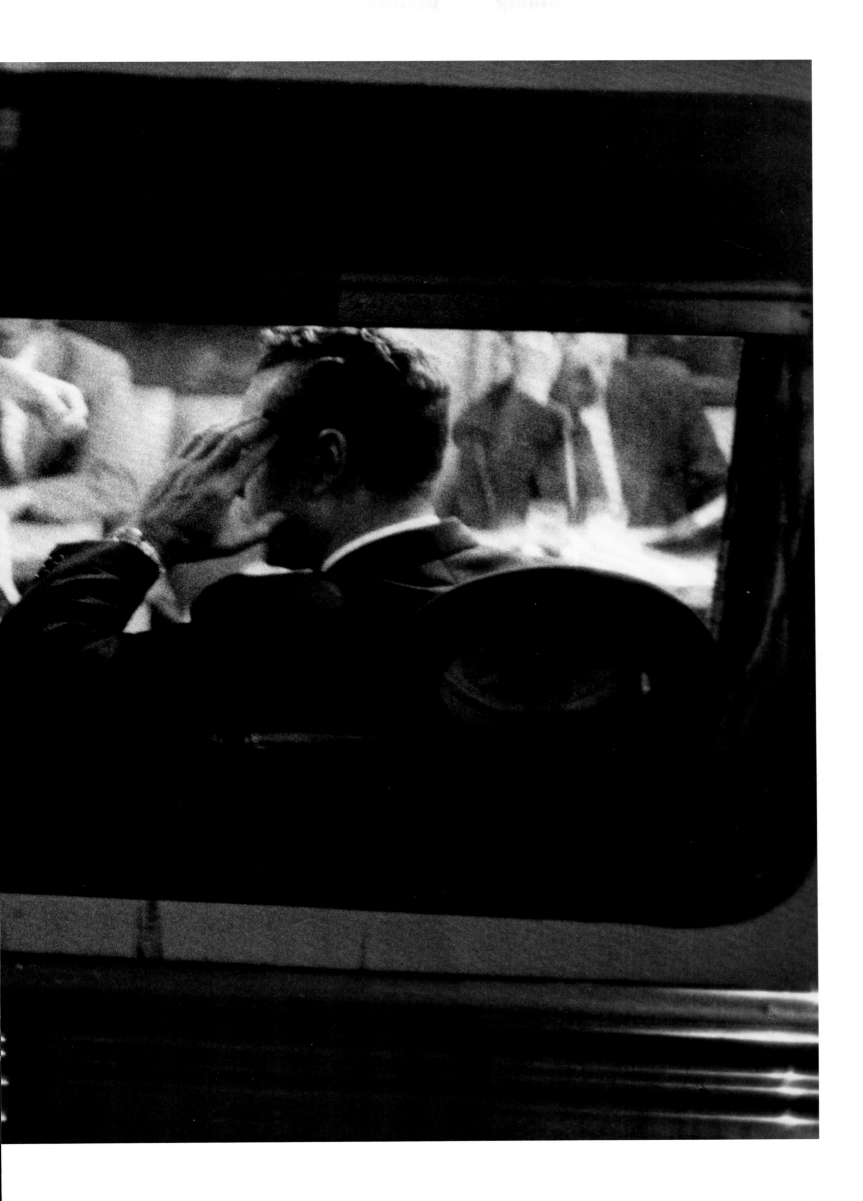

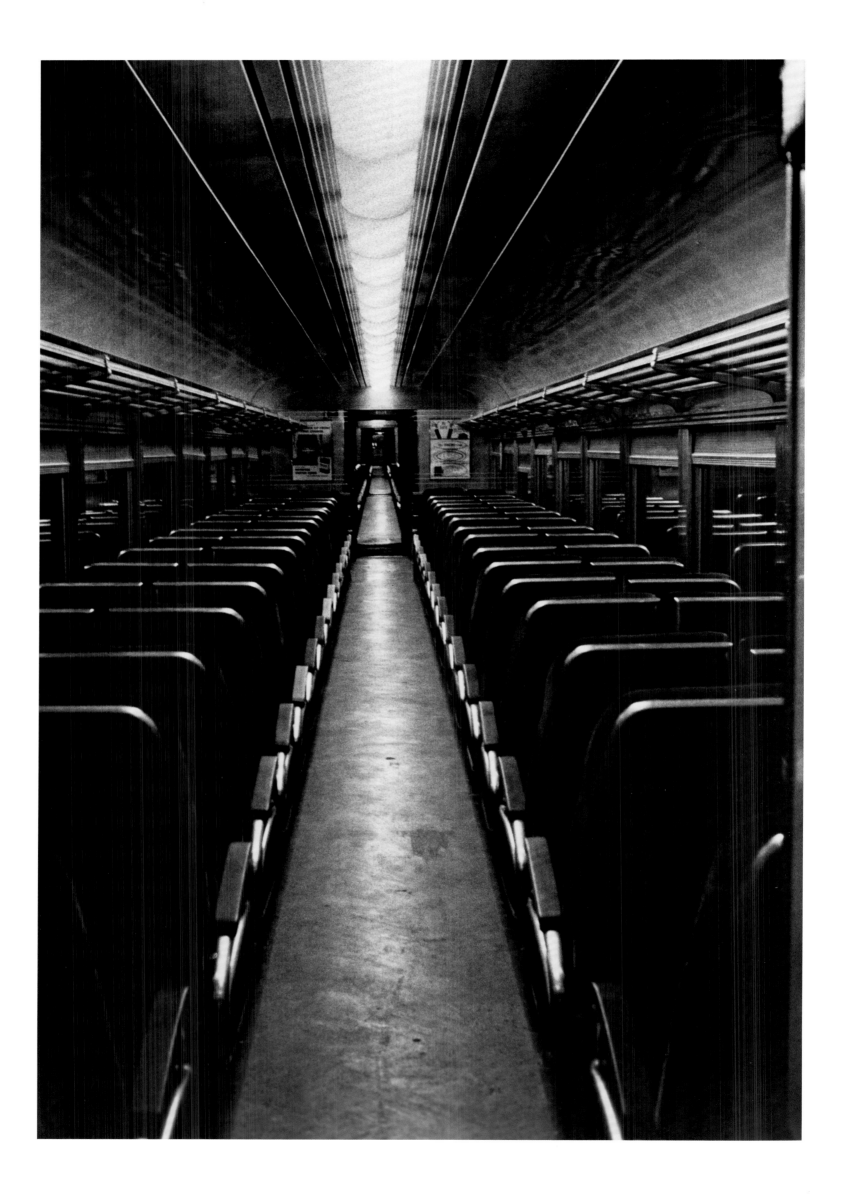

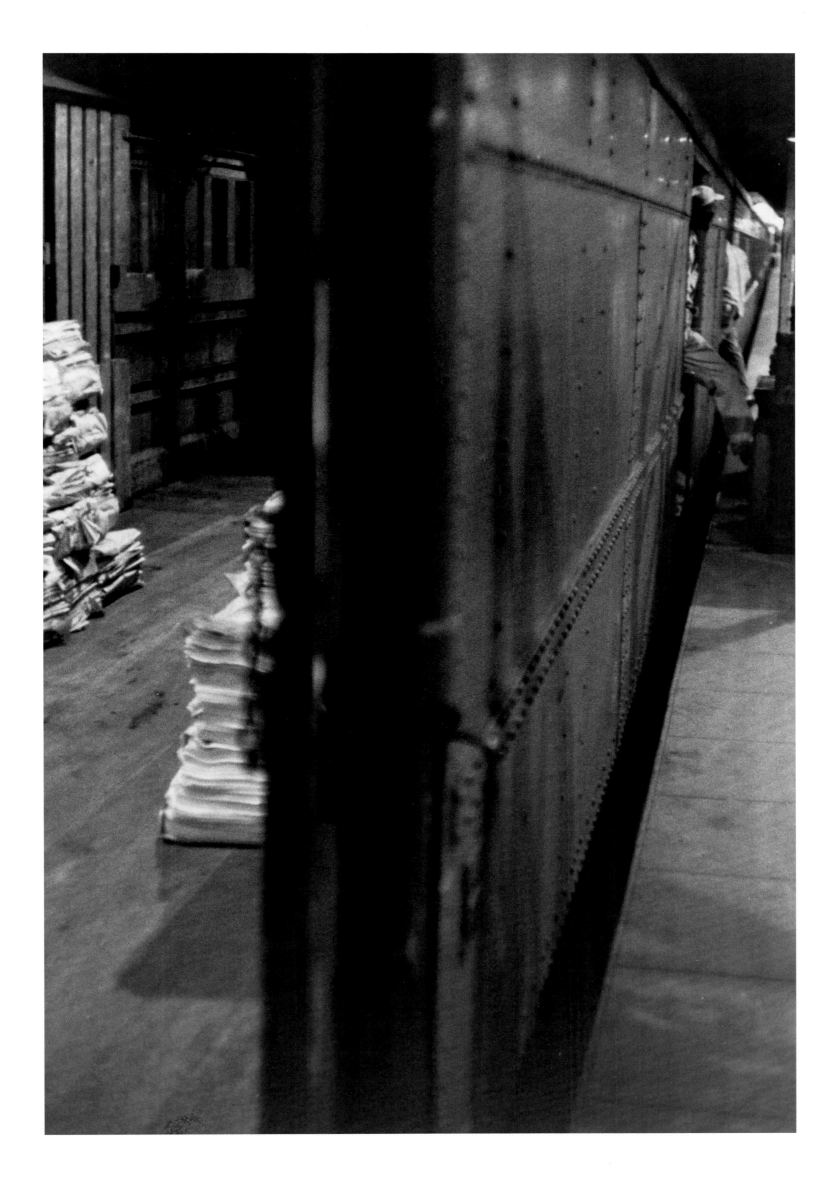

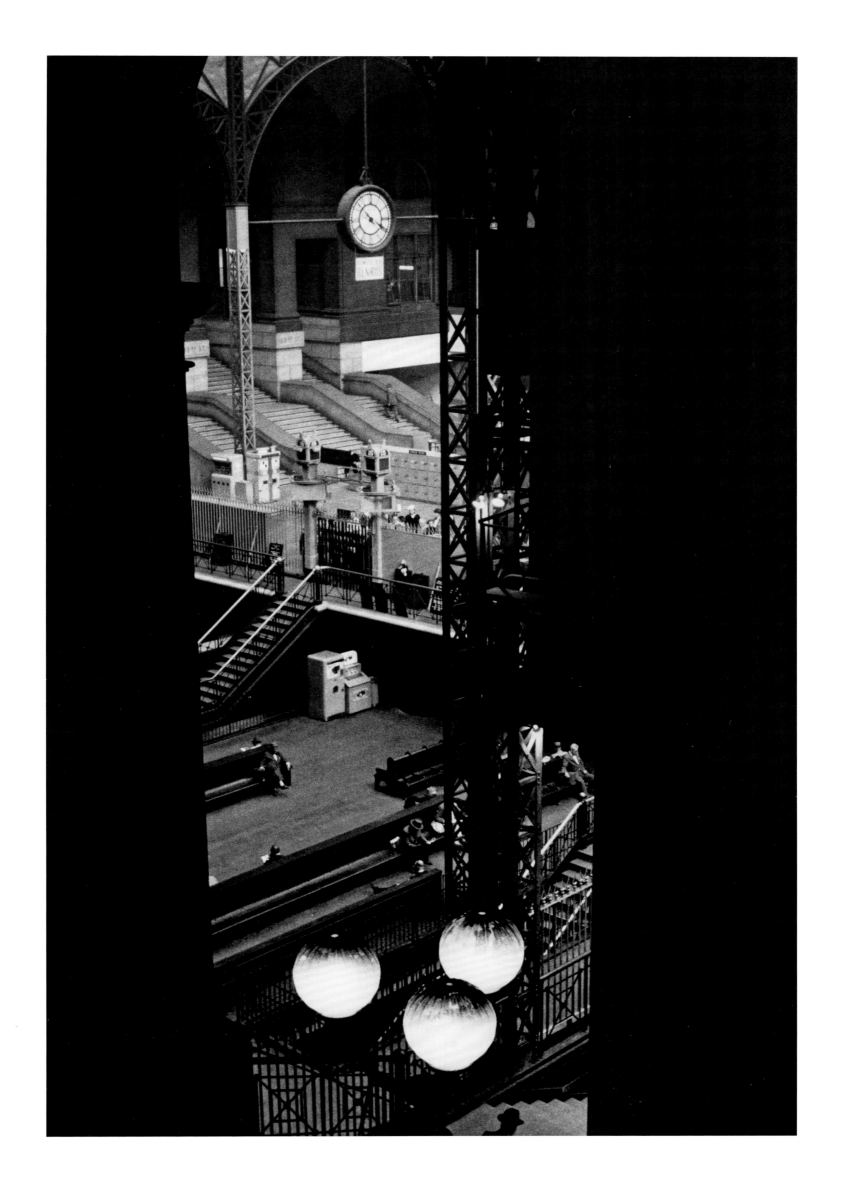

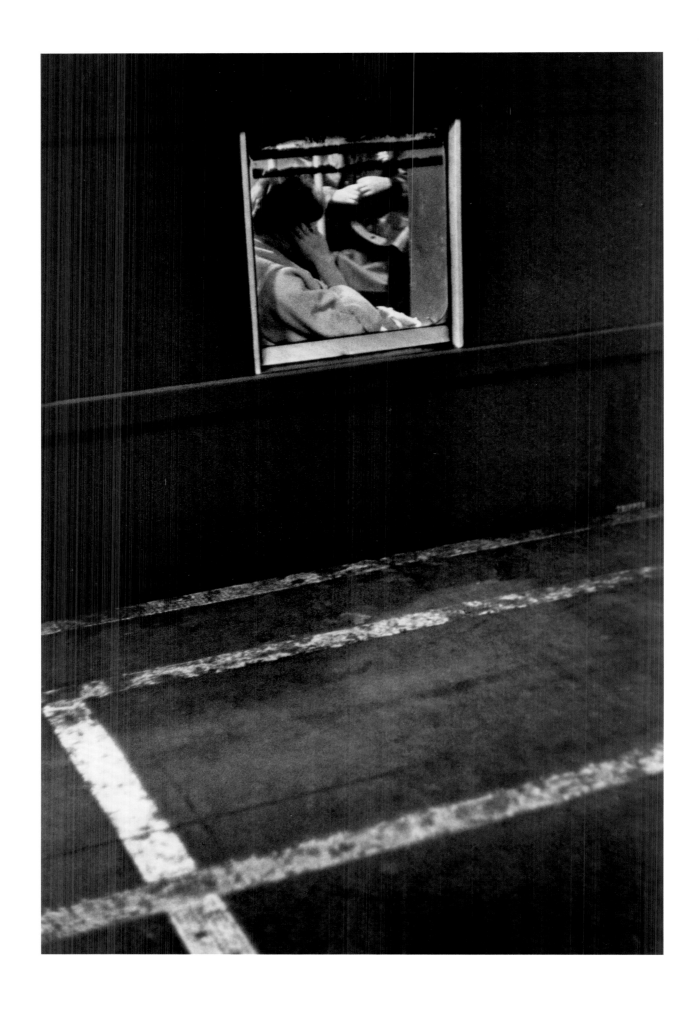

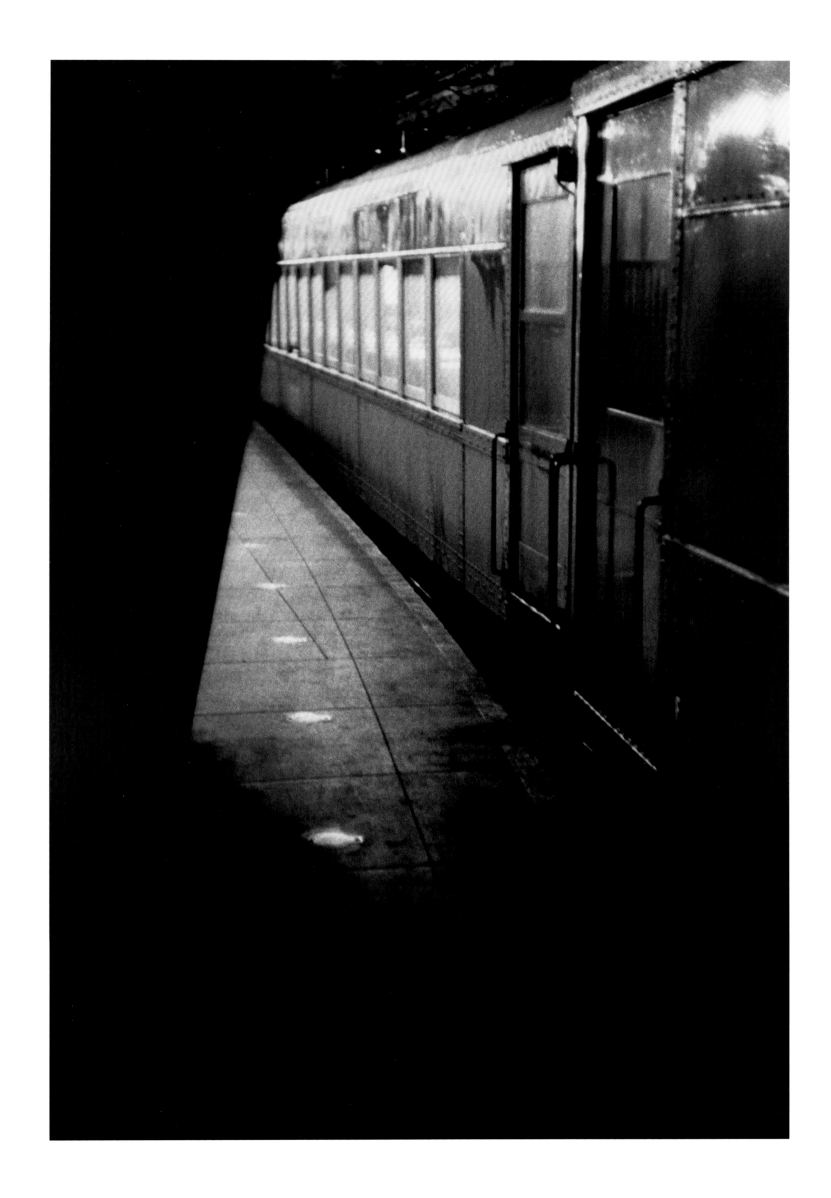

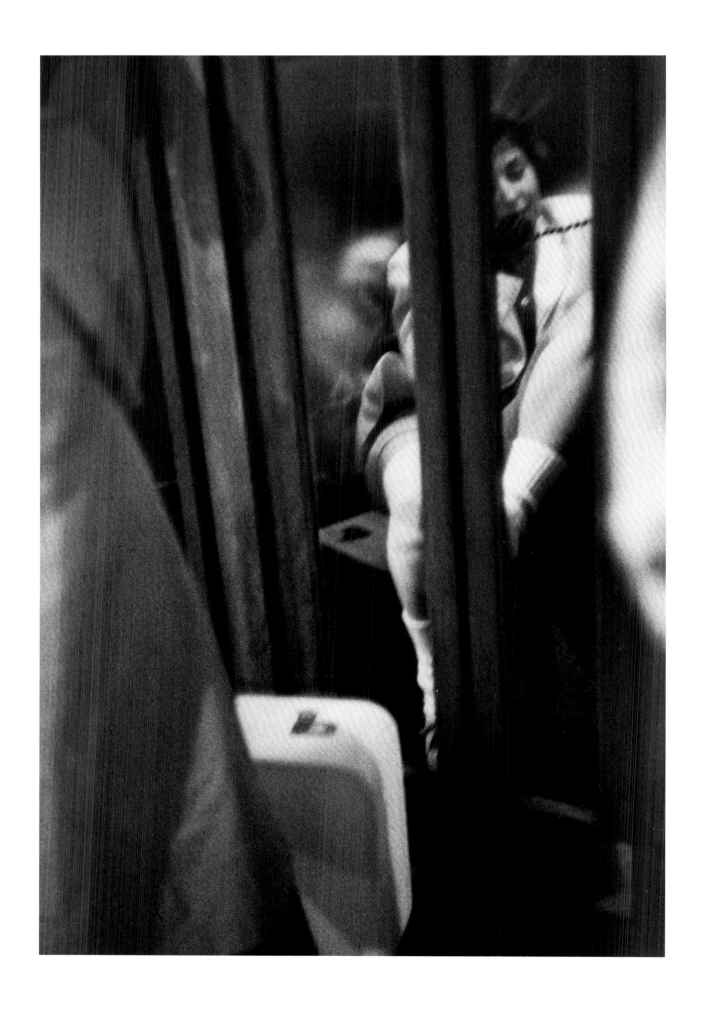

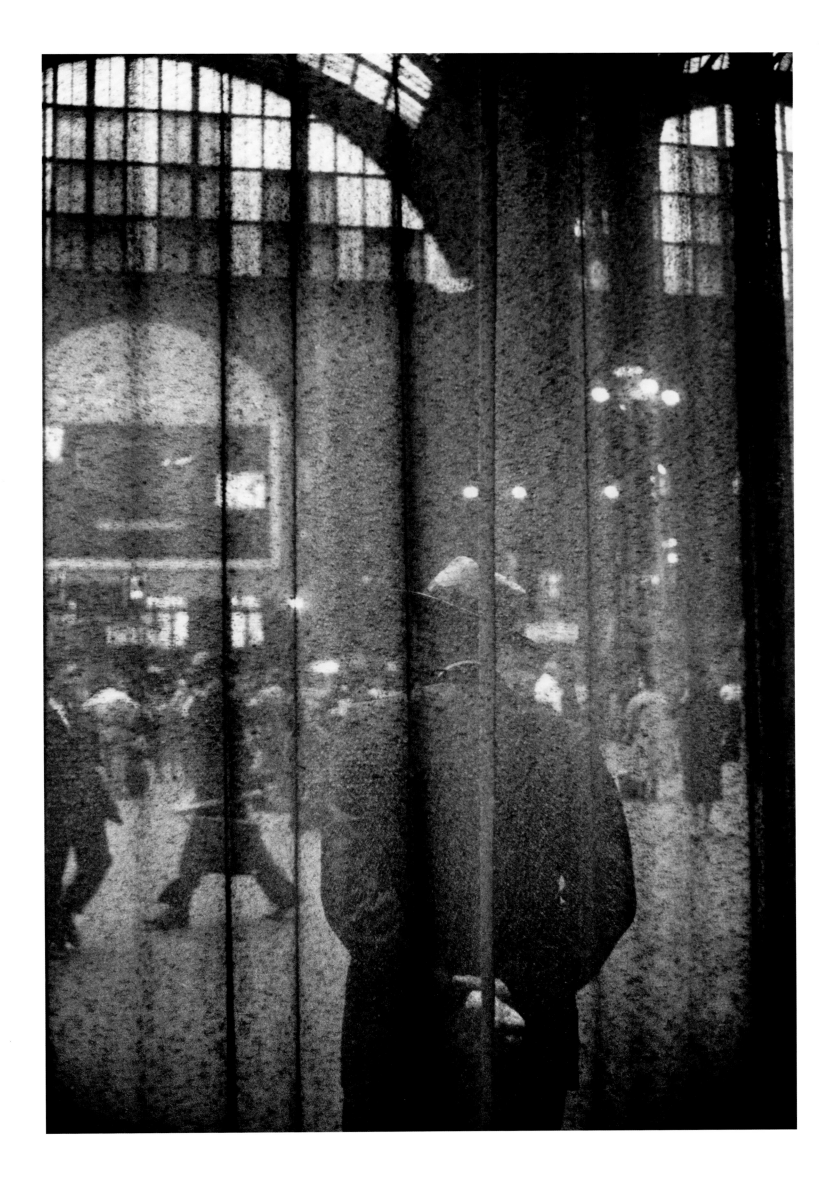

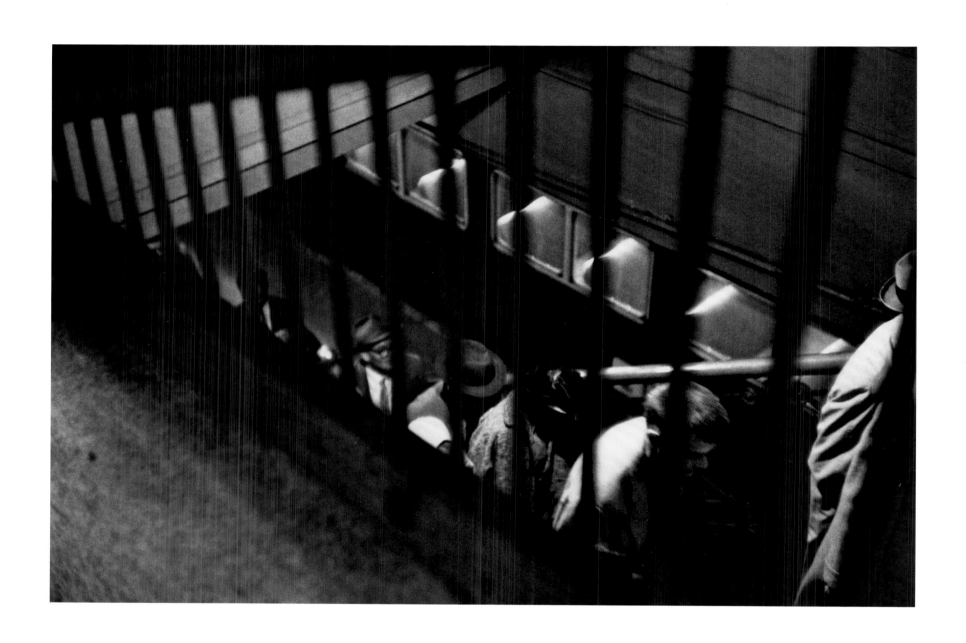

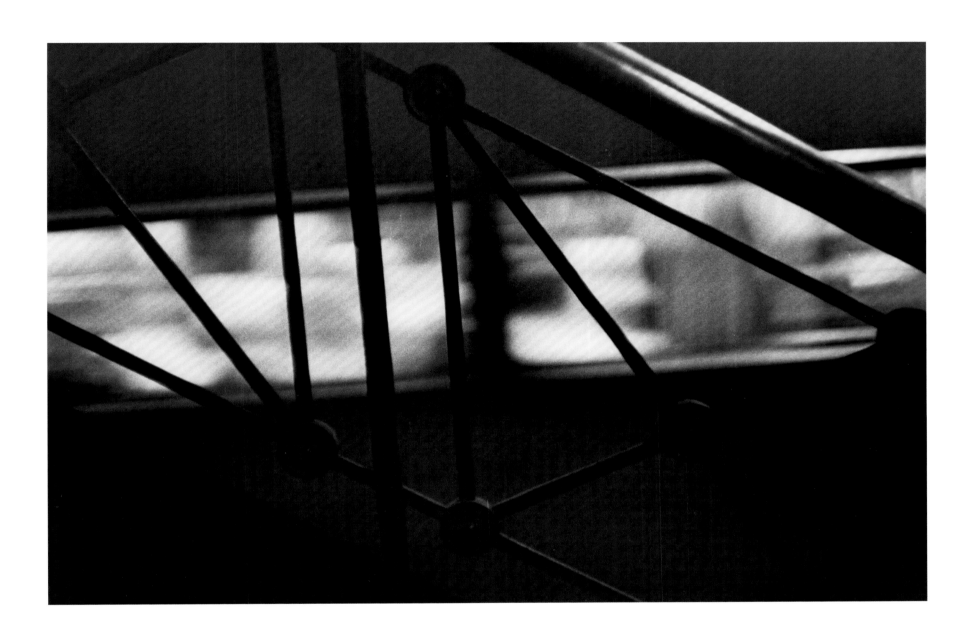

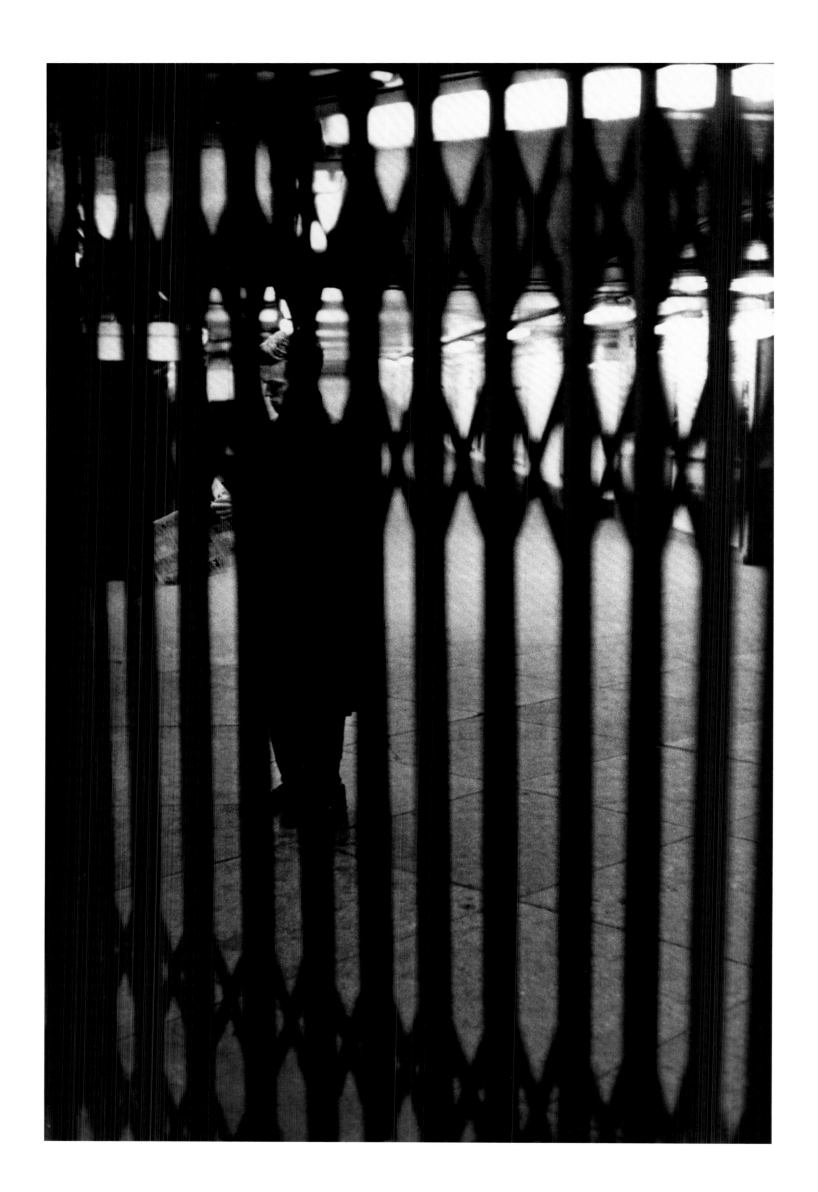

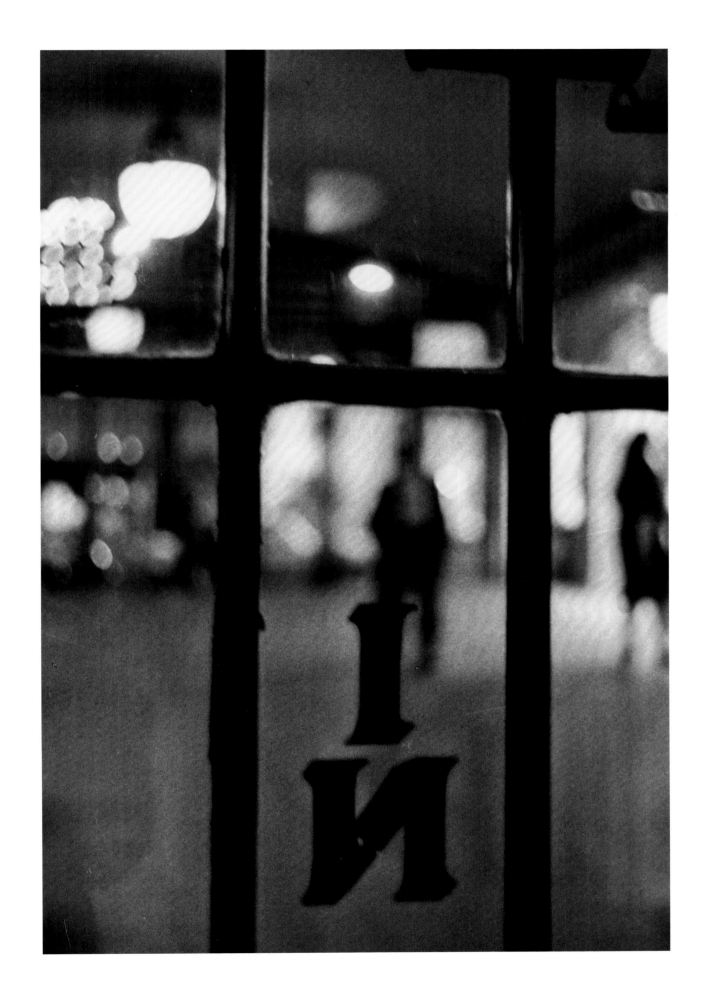

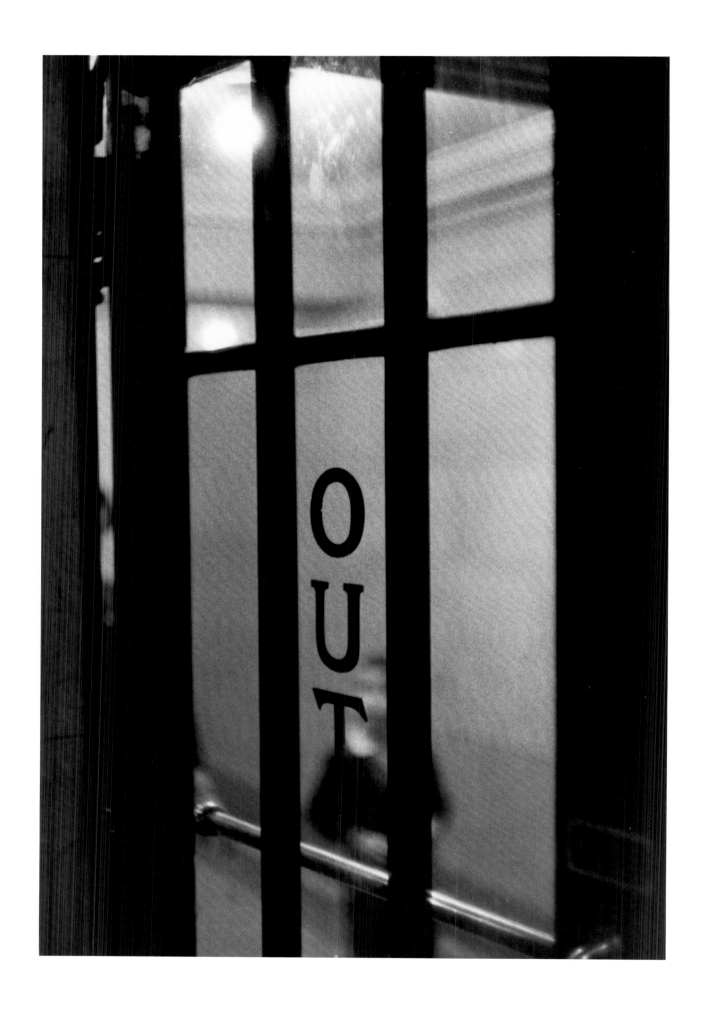

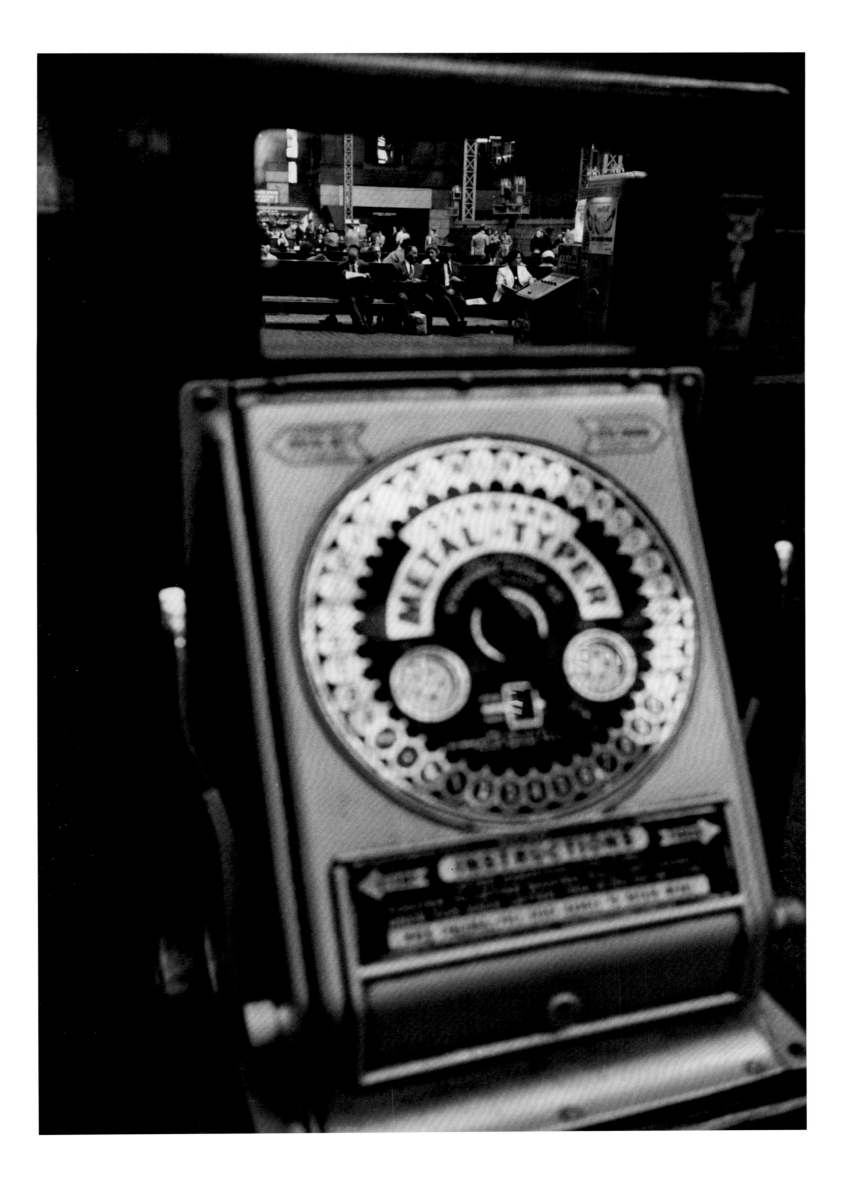

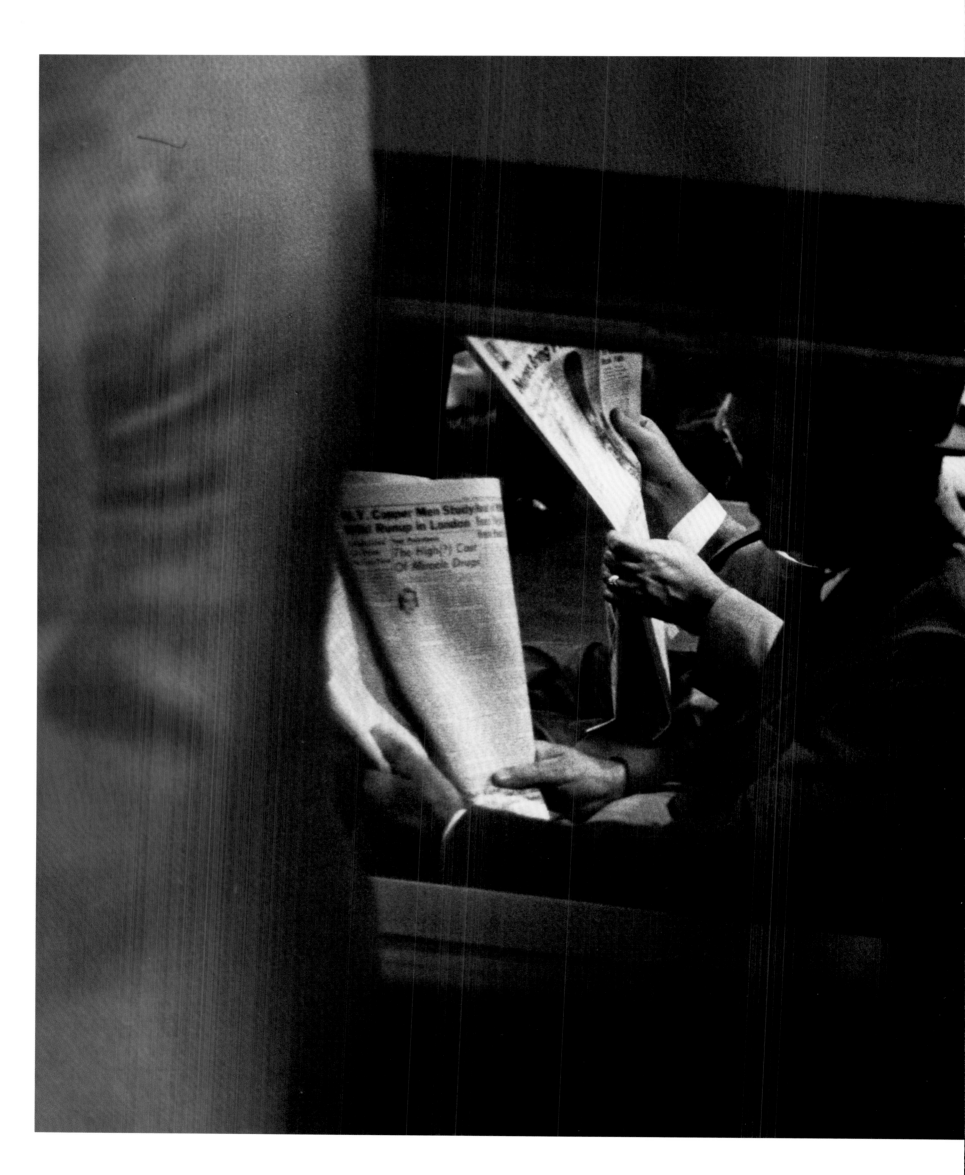

I once said: "My way of life, my very being, is based on images capable of engraving themselves indelibly in our inner soul's eye." I would add that it is also to explore and celebrate the human condition and the world around us, nature and man together, to find significance in suffering, to reveal all that is profound, beautiful, and that enriches the soul. Above all, I believe in creative work through struggle to increase human wisdom and happiness.

—Louis Stettner

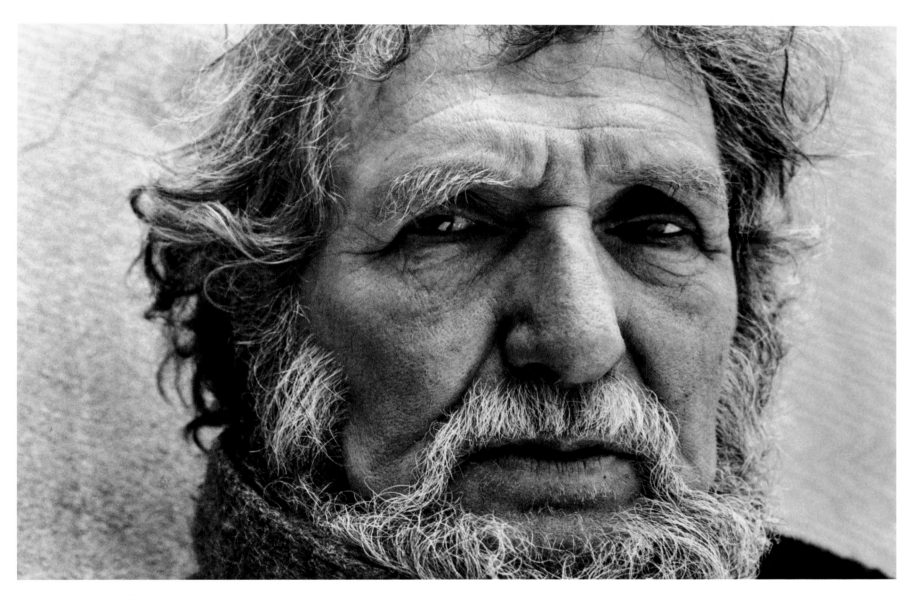

Photograph by Janet Iffland

THE POET OF THE MAGNIFICENT ORDINARY

Raphaël Picon

Louis Stettner's photographs are made of the soul and the flesh of Pennsylvania Station. The railway's superb monument provided him with the space and density necessary to host his talent and to make it burst out. Louis Stettner is a past master in composition. The complexity of the railway station, where so many details are combined to shape a majestic architecture, must have been such an exciting challenge for a photographer so much influenced by the compositional genius of the Flemish painter Pieter Bruegel the Elder.

For many reasons, Stettner appears to us a poet of the ordinary, an ordinary that is revealed as nothing less than magnificent.

Stettner's photographs of Penn Station deal with all the beauty offered to daily commuters. A monumental cathedral hall, immaculate marble walls, sumptuous glass canopies, gigantic stairs, impeccable coppers, beautifully carved lintels, sophisticated twisted woodworks: Penn Station was indeed an architectural jewel. On his arrival at Penn Station, the traveler must have been won over by the pride of the place. He could feel good and empowered by so much luxury; he was made ready to start his day and to conquer the world. The commuter was magnified as well as appeased by such beauty. The railway station worked as a transitional space, securing the passage between home and work, the intimate and the public, the known and the unknown. It gave him space, brought him heights, expanded his own vision. It also strengthened his self-confidence and self-esteem.

From Stettner's work, one has the feeling that magnificence was at that time given to ordinary public arenas as a way to value what was shared by all—a common space cementing our social life. We all seem so much alike in a train compartment but we are still so different. A certain promiscuity unique to the commute alters the borders

of our bodies: we are intimately joined to our neighbors and yet remain strangers. Railway stations tie individuals to one another and lead them into a common destiny. The wideness of Penn Station, the hugeness of its halls, staircases, platforms, were to allow a great variety of paths of life and to protect the integrity of each of them.

Taking the most simple and direct approach to his subjects, Stettner finds the perfect vantage point in each shot that enables him to shape a photography made of straight and broken lines, of symmetrical and asymmetrical repetitions, of succeeding backgrounds. The process gives emphasis to reality, widens our vision and roots us deeper in the photographer's world. There are no tricks in Stettner's photography. No cleverness. His purpose is not to disguise reality, nor to distort it, to make it look better, less bland and more vibrant. Nor is the purpose to use reality as an intellectual medium, bearing a specific message. Stettner shapes our eyes, he forms our vision, he teaches us to feel reality, just as it is, in its inner complexity, its variety of lights and the profoundness of its shadows, its unseen connections, its internal structures. Louis Stettner stands here in the good company of his old fellow photographers: Lisette Model, Louis Faurer, Paul Strand. . . . Our common reality appears to be far more interesting than one would ever have thought it could be. The photographer intensifies how we see, puzzles us with what appears to be the unknown at the very heart of the familiar.

As a photographer, Stettner brings so much life to Penn Station that he is now forced to recognize his own defeat in his attempt to capture it, to apprehend its inner dynamics. The good thing about a series of photographs on one theme is that it leaves its photographer enough time to be grasped by the subject itself, to be overwhelmed by its energy. We witness here a creative inversion. It is not so much the photographer that makes the decision on the best way to capture what will eventually become the content of the photographs. It is now the subject itself that takes the lead, that imposes its decisive meaning, that lures the photographer's eye and obliges him to press the button. Stettner is so intimately linked to Penn Station that he deeply honors his subject. This is the reason why his photographs have transcended his own notoriety. Stettner is left in the shadow of his own photography.

Louis Stettner shows us women, children, men who are engaged in their own actions. They all belong to their distinctive worlds: a little girl dancing in the light, a young woman who has fallen asleep, a sailor totally devoted to some secret thoughts,

men entirely committed to the news of the world. . . . Things that elsewhere would look meaningless here become so attractive. In Stettner's photographs every detail matters and everyone becomes someone. Moreover, by exploring and displaying for us the interest of the ordinary, Stettner brings us back home. He endorses the mission assigned to the poet by the great American nineteenth-century thinker Ralph Waldo Emerson:

> The fate of the poor shepherd, who, blinded and lost in the snow-storm, perishes in a drift within a few feet of his cottage door, is an emblem of the state of man. On the brink of the waters of life and truth, we are miserably dying. The inaccessibleness of every thought but that we are in, is wonderful. What if you come near to it,—you are as remote, when you are nearest, as when you are farthest. Every thought is also a prison; every heaven is also a prison. Therefore we love the poet, the inventor, who in any form, whether in an ode, or in an action, or in looks and behavior, has yielded us a new thought. He unlocks our chains, and admits us to a new scene. (Ralph Waldo Emerson, "The Poet," *Essays: Second Series*, 1844)

The poet, because of his language skills, appears to be the one to take full credit for widening our own world by making us feel anew our familiar realms. At the very heart of this uncertain world where no one can immunize himself from the injuries of life—a world as complex and puzzling as a major urban train station—Stettner, like Emerson's poet, helps us find our way home. In Louis Stettner's photographs, there is always a well-laid table and a cup of coffee, there is always a girl dancing in the shadow of a circle of light, there is always a comfortable leather couch where one can rest and fall asleep.

But the ordinary is by nature ambivalent. It lies at the common source of authenticity and conformism. And this is also shown in Stettner's photographs. All those men leaving at the same time, wearing the same suits, reading the same news, sharing the same vision of the world. The photographer has remained on the platform and we with him, watching those men leave to lead the world and enrich its news, which they will read in tomorrow's paper. This conformism contrasts with all those daily intrigues that invade Stettner's camera: the vibrant phone call made by this lively woman, the mysterious woman alone on the platform and sustained in her walk by neon lights.

All those details are suggestive enough to compel us to invent stories about the woman on the phone, the businessman, the little boy, and make us feel that the world, our world, is not limited to what Stettner shows us. And this is why his photographs are so powerful. Their strength is in making us see what they don't show. The heart of the action is left behind. They lead us to feel the infiniteness of the world that no frame can restrain. A railway station combines the here and all possible elsewheres; it is a transitory place making us feel that we are neither in nor out. The *In* and *Out* of two of Stettner's photographs make us wonder where we stand . . .

Of course, the Penn Station series is not only about the train station, it is about all the intrigues the station bears, all the lives it holds and the affinity we feel for them. Another trait of Stettner's genius here is his ability to make us feel sympathy with all those characters; even with these severe-looking men on the train! The strength of the sympathy we feel overcomes the nostalgia we could easily have felt for this architectural jewel destroyed by real estate speculation. The attraction we feel toward those people makes us enter their world. We are now bound with them in Penn Station.

The train station is gone but lives forever thanks to Louis Stettner. Looking at his photographs today, one has the uncanny feeling that this architectural marvel must have been built to host the photographer's genius, his great poetry of the magnificent ordinary.

AFTERWORD

Louis Stettner

Many people ask me about my intention in taking the Penn Station series. That is not an easy question to answer. I felt powerfully pushed to photograph it for many complex and intuitive reasons. As Matisse wrote, "It sometimes takes the artist a long time to understand what he has done." I suppose I was following in the tradition of other photographers like Stieglitz and Hine, and the artist Daumier. Like them, I make my fellow human beings my main subject matter. When they travel, people are "on the big stage," so to speak. At heart, my life's work with the camera is to interpret the world around me through my personal vision.

I had started photographing the subway in 1946 and would occasionally shoot in Penn Station until 1958, when I did it full time. I loved the place and what was happening there. It was a spacious and dramatic arena where people in the act of traveling went through a mixture of excitement, a silent patience for waiting, and an honest fatigue.

The station itself was a mixture of glowing white marble and mysterious dark caverns, where time seemed to stand still. I remember it was very easy and natural to take photographs. After getting routine permission, no one—absolutely no one—ever objected to their picture being taken. In fact, they were often very friendly. It was a long moment of peaceful, creative quiet, yet one replete with deep human drama. I was very happy and really exhilarated to photograph there. It was also a time of rapid economic growth and cultural change in New York. More and more, working Americans were moving to the suburbs, and daily travel became an important part of their lives.

Only time reveals the value of creative photographs. If they have true significance, they will grow more alive and important with the years. The meanings they radiate will never be final or exhausted. On the contrary, with the passing of time, new hidden aspects in the photographs will be revealed.

BIOGRAPHY

Louis Stettner was born (1922) and raised in Brooklyn, New York. He began taking photographs at the age of thirteen and frequented the photography collection of the Metropolitan Museum of Art and Alfred Stieglitz's gallery An American Place. Both Stieglitz and Paul Strand, who would later become a friend, encouraged Stetter in his pursuit of photography. He served as a combat photographer in the Pacific theater during World War II. On his return to New York, he joined the Photo League, where he studied and taught. He became friends with Sid Grossman, founder of the Photo League, and met Lewis Hine and Weegee. In 1947 he moved to Paris, where he met Brassaï, who would become his mentor, Édouard Boubat, Willy Ronis, Izis, and Robert Doisneau. He organized the first exhibition in the United States of postwar French photography for the Photo League. He studied film at the Institut des Hautes Études Cinématographiques (IDHEC), University of Paris, and traveled throughout France and Europe. He began exhibiting his work and working as a freelance photographer for *Time, Life, Fortune, Du,* and other publications. In 1951 he was one of the top prizewinners in Life's Young Photographers Contest, which launched the postwar generation of American photographers. Since the 1940s, Stettner has moved back and forth between Paris and New York, photographing both cities extensively. In the 1970s Stettner was more often in New York and teaching at Brooklyn College, Queens College, and the Cooper Union, and later at the C. W. Post Center, Long Island University, and also lecturing at the International Center of Photography. In 1990 he settled permanently in Saint-Ouen, outside Paris, though he kept his New York apartment until 2014. Now in his 90s, he continues to photograph and he also paints and sculpts.

BOOKS BY LOUIS STETTNER

Louis Stettner: Sophisme, photographies 1990–1999. Text by Michèle Auer. Neuchâtel: Ides et Calendes, 2001.

Louis Stettner: Wisdom Cries Out in the Streets. Paris: Flammarion, 1999.

Louis Stettner. Introduction by François Bernheim. Paris: Nathan, Collection Photo Poche, 1998.

Louis Stettner: American Photographer, Paris. Catalogue by Hilary Schmalbach. Aachen: Suermondt-Ludwig-Museum, 1996.

Louis Stettner's New York, 1950s–1990s. Introduction by Barbara Einzig. New York: Rizzoli International Publications, 1996.

Sous le ciel de Paris. Preface by François Cavanna. Paris: Parigramme, 1994.

Early Joys: Photographs from 1947–1972. Introduction by Brassaï. New York: Janet Iffland, Publisher, 1987.

Sur le Tas. Introduction by François Cavanna. Paris: Cercle d'Art, 1979.

SELECTED COLLECTIONS

Addison Gallery of American Art, Phillips Academy, Andover, Massachusetts
Art Institute of Chicago
Bibliothèque Historique de la Ville de Paris
Bibliothèque Nationale de France, Paris
Brooklyn Museum of Art
Cleveland Museum of Art
International Center of Photography, New York
Jewish Museum, Berlin
The Jewish Museum, New York
The Los Angeles County Museum of Art
La Maison Européenne de la Photographie, Paris
The Metropolitan Museum of Art, New York
Montana Museum of Art & Culture, University of Montana, Missoula
Musée Carnavalet, Paris
Musée de l'Elysée, Lausanne
Musée National d'Art Moderne, Centre Pompidou, Paris
Museum of the City of New York
Museum of Fine Arts, Boston
The Museum of Modern Art, New York
National Gallery of Art, Washington
New York Public Library, New York
San Francisco Museum of Modern Art
Smithsonian American Art Museum, Washington
Victoria and Albert Museum, London
Whitney Museum of American Art, New York